Peter Vergo

THE
BLUE RIDER

PHAIDON

For Sara

Phaidon Press Limited, Littlegate House, St Ebbe's Street, Oxford
Published in the United States of America by E. P. Dutton, New York

First published 1977

© *1977 Elsevier Publishing Projects SA, Lausanne/Smeets Illustrated Projects, Weert*

ISBN 0 7148 1749 x
Library of Congress Catalog Card Number: 77-75307

Printed in The Netherlands

THE BLUE RIDER

The name 'Blue Rider' symbolizes, for us, that renewal of German art which occurred in Munich during the years immediately before the First World War. It recalls a book, two exhibitions, and a fraternity of artists sharing a common ideal. However, the Blue Rider was never a movement nor, strictly speaking, an exhibiting society. It was an idea in the mind of one man, a Russian named Vasily Kandinsky. In 1896, at the age of 30, he had abandoned a promising academic career in order to devote himself to painting, which had seemed to him, in his youth, 'an inadmissible luxury for a Russian'. He was attracted to Munich, whose art schools enjoyed a high reputation in Russia at that time. He studied at the private school run by the painter Anton Azbé, together with a number of other Russian artists including Ivan Bilibin, Igor Grabar and Dmitri Kardovsky. He was also admitted to the painting class of the great Franz von Stuck, professor at the Munich Academy. Although Kandinsky found the academic study of painting uncongenial, in later life he remembered Stuck's teaching with gratitude. In 1902 he met the young German artist Gabriele Münter, who was to become his constant companion. Münter described Munich at this time as the 'city of *Jugendstil*', and the influence of *Jugendstil*, the German variant of Art Nouveau, is clearly visible in Kandinsky's earliest paintings from the beginning of this century.

In 1904 Kandinsky and Münter left Munich and set off on their travels. During the next four years they wandered as far afield as Italy, North Africa and Russia. They stayed a whole year in Paris, from summer 1906 to summer 1907, and spent the winter of 1907–8 in Berlin, returning to Bavaria in the spring. Münter bought a small country house in Murnau, a summer resort a few miles south of Munich. The village and its surroundings provided the inspiration for many of their landscapes of the years 1909–10 (Plate 2). In Murnau the two artists gathered around them a number of Kandinsky's compatriots (Münter's cottage is still known locally as the 'House of the Russians'). Among them were the painter Alexei von Jawlensky who, like Kandinsky, had studied at Azbé's school, and his companion, Mariamne Verefkina (Marianne von Werefkin). Another frequent visitor was the Austrian writer and graphic artist Alfred Kubin. The group was essentially Symbolist in orientation; their interests included contemporary mysticism and Wagner's ideas about a synthesis of the arts. They were also appalled by the low standard of art being produced in Munich, as seen in the exhibitions of the Secession and other groups such as *Die Scholle*. Kandinsky and his friends decided they could do better. In 1909 they founded an exhibiting society called the *Neue Künstler-Vereinigung München* (New Artists' Association of Munich). Its aims were to promote exhibitions both in Germany and abroad, and to organize lectures, publications and other related events. Kandinsky was the first president, Jawlensky vice-president. Ordinary members included the painter Vladimir Bekhteev, the sculptor Moshe Kogan, and the dancer Aleksandr Sakharov.

3

The first exhibitions of the *Neue Künstler-Vereinigung* (December 1909 and September 1910) were held in the prestigious gallery belonging to the Munich dealer Heinrich Thannhauser. Kandinsky had struck up a friendship with the newly appointed director of the Bavarian State Collections, Hugo von Tschudi, who interceded with Thannhauser on behalf of this society of largely unknown artists. The exhibitions created a furore. The critics protested. The public was outraged. According to Thannhauser, it was his unpleasant task each evening, after the gallery had closed, to clean the spit off the pictures. Kandinsky's paintings were found particularly offensive. One critic described *Composition 2*, shown at the second exhibition, as 'an involuntary conglomeration of colours', and went on to compare the painter's philosophy of art to 'the cackling of a lame hen'. 'We were amazed', Kandinsky wrote, 'that in the whole of Munich, "city of art", no one except Tschudi had a word of sympathy for us.' And then, one day, the long-awaited word came:

> Thannhauser showed us a letter from an unknown Munich painter, who congratulated us on our exhibition and expressed his enthusiasm in glowing terms. This painter was a 'real Bavarian', Franz Marc. At that time he was living in a farmhouse in Sindelsdorf . . . We soon made his personal acquaintance, and saw that his exterior corresponded exactly to his inner nature: a tall man with broad shoulders, a firm tread, an expressive face with highly individual features, revealing an unusual combination of power, incisiveness and good temper. In Munich he seemed too tall, his gait too long . . . His free nature was that of the countryside, and I always took a particular pleasure in watching him walk through meadows, fields and woods with a rucksack on his back and a stick in his hand. His organic relationship with nature was reflected in his bond with his dog 'Russi', a large white sheepdog, whose manner, strength of character and sweetness of temper made him a perfect four-legged copy of his master.

Marc was to play an important part in Kandinsky's life, not least by introducing him to the publisher Reinhard Piper. Piper enabled Kandinsky to realize his most cherished ambitions: the publication of his treatise, *On the Spiritual in Art*, which came out in December 1911, and of his poems and woodcuts, which were gathered together in the album *Klänge* (Munich, 1913). But of all the art books published by Piper, by far the most important, not just because of its scope, but because of its influence upon twentieth-century art, was the *Blue Rider Almanac*.

The Almanac was initially Kandinsky's idea. In a letter to Paul Westheim, editor of the periodical *Das Kunstblatt*, he recalled his original aims, his desire

> to compile a book . . . in which the articles would be written exclusively by artists. I dreamed of painters and musicians in the front rank. The harmful separation of one art from another, of Art from folk art or children's art, from 'ethnography', the stout walls which divided what were to my mind such closely related, even identical phenomena, in a word their synthetic relationships – all this gave me no peace. Today, it may appear remarkable that for a long time I was able to find no collaborator, no resources, simply no support for such a project . . .

4

And then came Franz Marc from Sindelsdorf.

One conversation sufficed: we understood one another perfectly. In this un-forgettable man I found then a rare instance (is it less rare today?) of an artist able to see far beyond the boundaries of mere 'trades unionism', someone who was inwardly, rather than outwardly, opposed to every form of restrictive, stifling tradition.

The *Blue Rider* was originally conceived as an annual or yearbook, although only the first number actually appeared. Kandinsky had thought of calling it ' "The Chain", or some such title'. However, both he and Marc liked the colour blue: Marc, horses; Kandinsky, riders. So, according to the latter, the name invented itself. Horses and riders were common motifs in Kandinsky's paintings of this period. The figure of a rider with flying cloak occurs in nearly all his preliminary drawings for the cover of the book. The final design (Plate 1) is, however, more complex than any of the preparatory studies. The leaping horseman is related to Kandinsky's various versions of St George and the Dragon, a theme which occupied him a good deal at this time. A Bavarian glass painting of this subject is visible in the background of Münter's *Still-Life with St George* (Plate 36). The figure at the lower right, on the other hand, derives from primitive devotional images of St Martin and the Beggar. We may also recognize in the features of Kandinsky's horseman a likeness to Marc.

Plans for the Almanac were well advanced by the autumn of 1911. The self-styled editors solicited friends and acquaintances for contributions, in the form of articles and essays. Marc's friend August Macke, then in Bonn, was asked to edit the considerable amount of ethnographic material to be incorporated in the volume. He also delivered an essay on primitive art, entitled 'Masks', which begins: 'A sunny day, a dull day, a Persian's spear, a sacrificial vessel' – the most elegantly written piece in the whole book. Meanwhile Kandinsky was writing letter after letter to the composer Arnold Schoenberg in Berlin, pressing him for a long-promised article, provisionally called 'On the Question of Style'. Kandinsky had been deeply impressed by a Schoenberg concert he had heard in Munich the preceding January, and had immediately recognized in the composer's music, and more especially in his ideas, a significant parallel with what he himself was trying to do in painting. We should be grateful for his refusal to take no for an answer. (*'First* number without Schoenberg? No, I won't have that!') Schoenberg's essay 'The Relationship to the Text', the manuscript of which arrived in Munich in January 1912, is one of the most important of all his theoretical statements. And when the Almanac was finally published, it included, in addition to this essay, reproductions of the composer's paintings, and a musical 'supplement', consisting of facsimiles of short pieces by Schoenberg and his pupils, Alban Berg and Anton von Webern.

The sheer quantity of musical material to be found in the Almanac is astonishing. Had the original plan been adhered to, music would have occupied pride of place; there were to have been no less than eight articles on music, compared with only six on painting. Even as eventually published, the Almanac contains, apart from the contributions of the second Viennese school, articles on 'Free Music' by Kandinsky's friend, the Russian military doctor and dilettante Nikolai Kul'bin; on 'Anarchy in Music' by the composer Thomas von Hartmann; and on Aleksandr Skryabin's *Prometheus, or the Poem of Fire* by

Leonid Sabaneev. Skryabin was another composer whose work greatly interested Kandinsky. *Prometheus*, in particular, seemed to bear out his own ideas concerning a possible synthesis of the arts, since it included a part for a colour organ, an instrument which produced no sound, but projected coloured lights on to a screen, according to an agreed system of notation. Correspondences between particular colours and particular musical tones are discussed in some detail in Sabaneev's article. Kandinsky also published in the *Blue Rider Almanac* a stage composition of his own, called *Yellow Sound*, which was intended to demonstrate his ideas about a new 'synthetic' art, capable of uniting all the individual arts in one single work – what he called the 'monumental art of the future'. His ideas on stage composition are, however, more akin to Schoenberg's than to Skryabin's. There is a remarkable similarity between *Yellow Sound* and Schoenberg's at that time unfinished music-drama *Die Glückliche Hand* (The Lucky Hand).

The idea of a synthesis of the arts had occupied Kandinsky for some time. As early as 1909, in a circular setting out the aims of the *Neue Künstler-Vereinigung*, he had referred to 'the search for artistic synthesis . . . which presently unites in spirit more and more artists'. In his treatise *On the Spiritual in Art*, he devoted considerable space to discussing the relationship between the different arts, and the way in which 'one art can learn from another'. The possibility of synthesizing individual art forms in order to create a 'total' work of art was a fashionable subject for speculation in the early 1900s. Ever since Wagner, artists and writers had been intrigued by the idea that different kinds of aesthetic response might reinforce one another, so as to produce an impression more powerful than that which any individual art could attain. Kandinsky would have had a lively interest in such questions, since there is little doubt that he himself genuinely experienced synaesthetic response – 'hearing' colours, 'seeing' sounds, and so on. In his *Reminiscences*, he recalled 'seeing all his colours in his mind's eye' during a performance of Wagner's *Lohengrin* which he had attended as a young man in Moscow. Apparently, he also had an extraordinary visual memory, a phenomenon often clinically associated with synaesthesia. 'Even as a boy', he wrote in the same essay, 'I was able to go home and paint by heart pictures that had particularly fascinated me at exhibitions . . . later I sometimes painted a landscape better "from memory" than after nature. Thus I painted *The Old City*, and later made many coloured Dutch and Arabian drawings.'

Interestingly, the *Blue Rider Almanac* was not the first 'synthetic' publication Kandinsky had contemplated. A drawing, now in Munich, of about 1909 bears the Russian inscription *Al'bom – Muzyka – Gravyury* (Album – Music – Prints). It was evidently intended as a cover design, and the fact that the inscription is in Russian is significant. A comparative volume of the kind Kandinsky envisaged was something of a novelty in Western Europe at this date. The idea had, on the other hand, quite a respectable pedigree in Russia. Sergei Dyagilev's journal *Mir Iskusstva* (The World of Art) frequently included substantial sections on music and literature. Kandinsky knew all about *Mir Iskusstva*; he even contributed an article to it in 1902, during his first stay in Munich. Even more important are the ethnographic journals of the Russian Imperial Academy of Sciences, which would have been familiar to Kandinsky from his student days. These journals sometimes appended to their reports on folklore and primitive usages illustrations of Russian primitive art, or Russian folk songs, tagged on to the end of the volume as a

6

kind of 'musical supplement', exactly like the three *Lieder* which feature in the appendix to the *Blue Rider Almanac*. One is impressed by the Russianness of the Almanac in general, with its numerous Russian contributions, ranging from Vasily Rozanov's 'Italian Impressions', previously published in *Mir Iskusstva*, to articles by Kul'bin and the brothers David and Vladimir Burlyuk, the leading representatives of the 'new wave' of Russian Futurism.

Another striking feature of the Almanac is the number of illustrations, which finally grew to more than 140. Apart from the 'Blue Riders' themselves, most of the leading figures of the European *avant-garde* were represented, starting with the three great precursors of modern art, Cézanne, Van Gogh and Gauguin, and ending with Matisse, Arp and Picasso. The various sizes of the reproductions reflected the editors' sense of priorities. Robert Delaunay, for example, is given greater prominence than the artists of the *Brücke* group, whose graphic works Marc had 'discovered' during a visit to Berlin over Christmas and New Year 1911–12. But the Almanac is by no means devoted exclusively to the moderns. More than half the illustrations are of the most heterogeneous objects – tribal carvings, Alaskan textiles, children's drawings, Easter Island sculptures, and paintings by El Greco and Douanier Rousseau. The care with which various illustrations are juxtaposed reflects the Almanac's didactic purpose. Sometimes, works from quite different cultures or periods are placed on opposite pages in order to make a specifically visual point. A Japanese woodcut facing Van Gogh's *Portrait of Dr Gachet* demonstrates the influence which Oriental prints exerted upon the Dutch artist. But more often, the editors' aim is to show, by means of the reproductions, the underlying affinity between modern art and the art of the primitives. Today, the term 'primitive' is used in a rather narrow sense, usually referring to tribal art, especially sculptures, carvings, religious objects, and objects of everyday use. But before the First World War 'primitive' covered the widest imaginable variety of styles and objects. The unknown and unappreciated, the art of 'the child, the Sunday-painter and the naïve' could all be subsumed under the heading 'primitive'. The term was meant to denote an identity of artistic purpose, rather than any visual similarity. Bavarian glass pictures, Romanesque sculpture and paintings by Picasso all found their way into the pages of the *Blue Rider*, not because they looked similar, but because they shared a certain expressive power. Their directness and vitality were undiminished by such trivial concerns as anatomical correctness, finish, or 'decorum'. It was, on the other hand, precisely this vitality which 'academic' art lacked – 'academic', like 'primitive', being understood in the widest sense. To judge by the *Blue Rider Almanac*, Kandinsky and his friends evinced a measure of disdain for what we might regard as the 'mainstream' tradition in European painting. Raphael, Michelangelo, Leonardo, Rembrandt, Poussin, Ingres and the neo-Classicists are all conspicuous by their absence.

Few of the major artists working in the first years of this century remained untouched by the influence of the primitive *per se*. This influence manifested itself in various ways. Picasso and Braque were fascinated by the formal qualities of African sculpture, which apparently reduced human anatomy to a geometric code. Ernst Ludwig Kirchner, Erich Heckel and the artists of the *Brücke* were impressed by the cave paintings of Ajanta in India, and by South Sea Island carvings. Kandinsky immersed himself in his Russian

heritage, drawing inspiration from icons, and from the *lubok*, a kind of primitive broadsheet which enjoyed a wide circulation in Russia during the eighteenth and nineteenth centuries. The imagery of the Russian nineteenth-century woodcut apocalypse is subsumed into his own paintings of these years immediately before the First World War. He was also intrigued by primitive techniques such as painting on glass – a medium still employed in Murnau by village craftsmen at that time. While in Bavaria, he made a number of experiments in this medium, adapting it to the apocalyptic imagery of the *lubok* – a curious marriage of cultures. Marc, Paul Klee and Heinrich Campendonk, an artist much admired by Kandinsky, also tried their hand at glass painting. Marc made his own version on glass of a self-portrait by Rousseau – a folkloristic tribute to the greatest of the modern 'primitives'.

Apart from the diversity of the illustrations, the scope of the *Blue Rider Almanac* is impressive for another reason. In the years before 1914, 'official' attitudes towards the arts were intensely chauvinistic, especially in Germany. Protectionism was rife. Kandinsky's friend von Tschudi had actually been forced from his position as director of the Berlin Gallery for buying too many French paintings, especially the works of the Impressionists. In 1911, only a year before the *Blue Rider* appeared, Carl Vinnen had edited a notorious pamphlet, entitled *The Protest of German Artists*. What the German Artists were protesting about was, of course, the excessive importation of French paintings into Germany. Kandinsky and Marc both contributed to a volume of essays, *The Struggle for Art – An Answer to the Protest of German Artists*, which Piper published as a direct response to Vinnen's attack. But the *Blue Rider*, with its self-confessed internationalism, was a far more effective reply. Its aim was to show that artists of different nationalities were animated by the same aims and ideals. The 'modern spirit' could transcend not only the traditional boundaries between painting and music or music and literature, but geographical boundaries as well. Beyond personal style and national style, beyond the accidents of time and place, lay something of greater importance – what Kandinsky christened 'the element of the pure and eternally artistic'.

The *Blue Rider* finally appeared in May 1912. It was dedicated to the memory of Hugo von Tschudi, who had died the previous autumn. But meanwhile, the editors of the Almanac had been overtaken by other events. As early as 1911, Marc had described in a letter to Macke the widening gulf between radicals and conservatives within the New Artists' Association. Kandinsky found himself especially isolated from most of the other members. His art had become highly individual, unlike anything else being produced at that time. During his first years in Murnau he had undoubtedly learned a great deal from Jawlensky. Their landscapes show a similar use of unmodulated colours, areas of colour often being bordered by a thick, dark outline. But by the end of 1911 he had progressed so far towards abstraction that his paintings appear at first sight entirely non-representational, although he had not, in fact, abandoned references to objects altogether. Instead, he 'dissolved' objects (his own word) by his use of colour, to such an extent that they are extremely hard to recognize – the apocalyptic rider, for example, in the left-hand part of *Improvisation 'Gorge'* (Plate 11). Only by prolonged study, and by looking across a range of works in which a given motif occurs, is it possible to recognize the basic themes which inform his work of this period – themes, for the most part, of

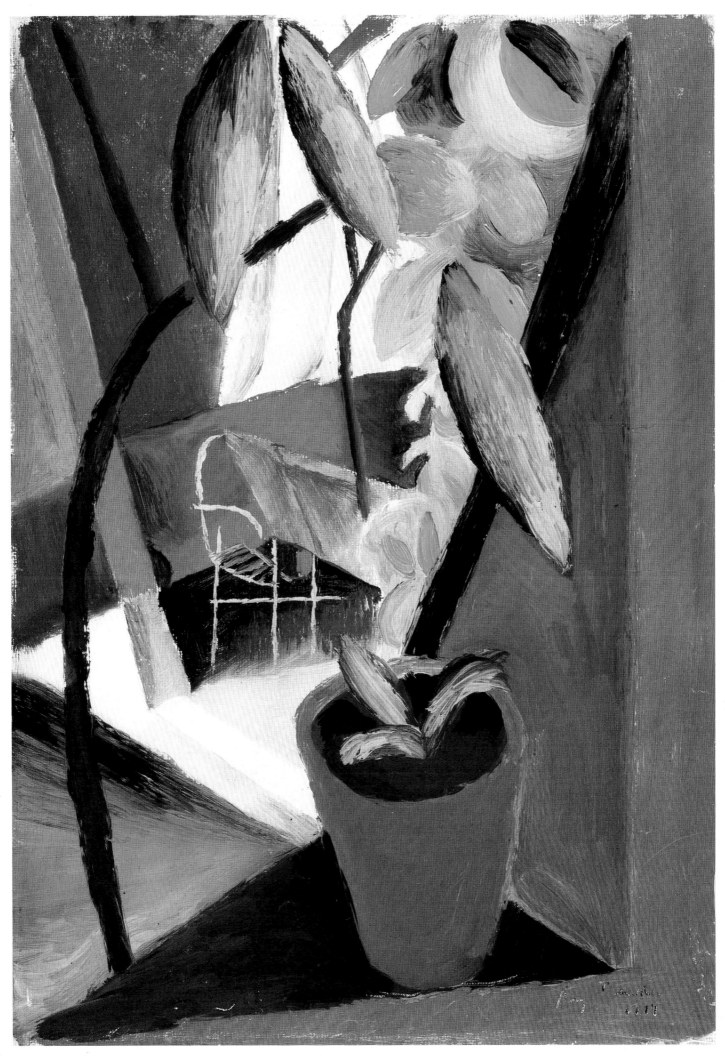

23. AUGUST MACKE: *Still-Life with Begonia*. 1914. Bonn, Städtische Kunstsammlungen

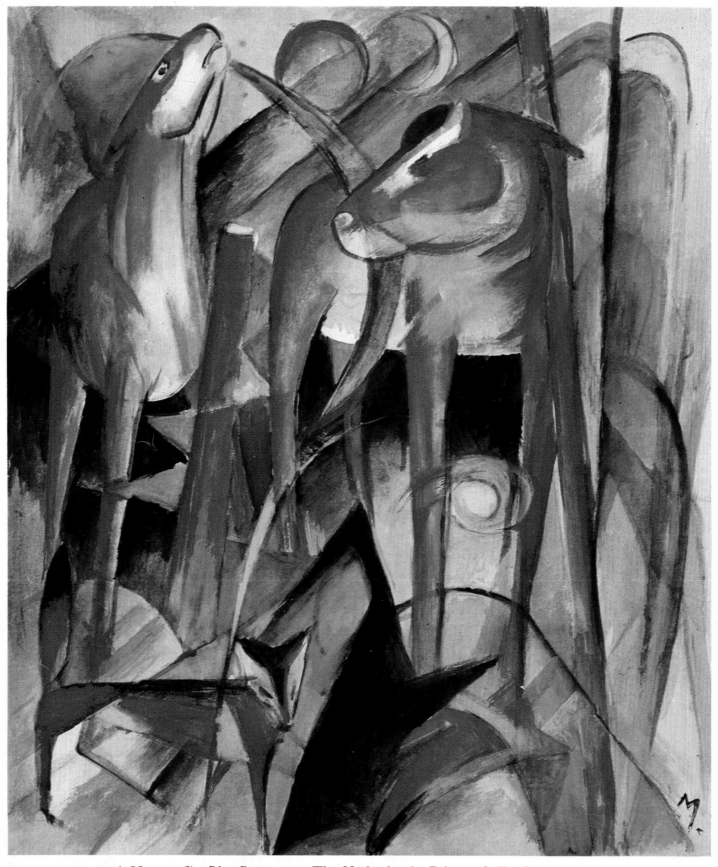

24. FRANZ MARC (1880–1916): *Blue Deer*. 1910. The Netherlands, Private Collection

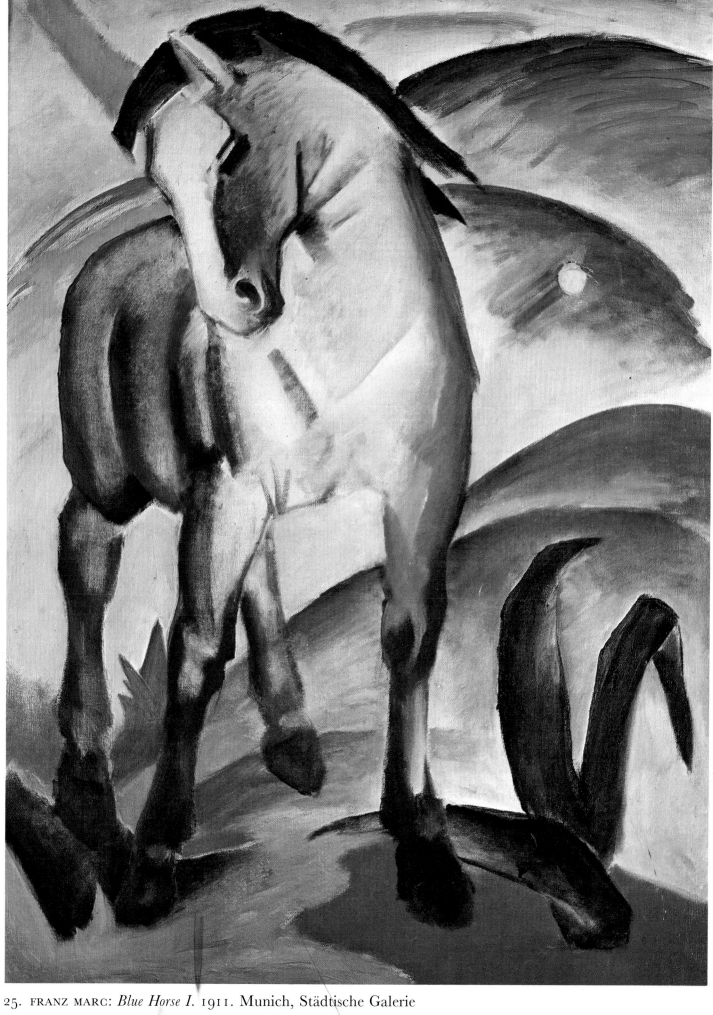

25. FRANZ MARC: *Blue Horse I.* 1911. Munich, Städtische Galerie

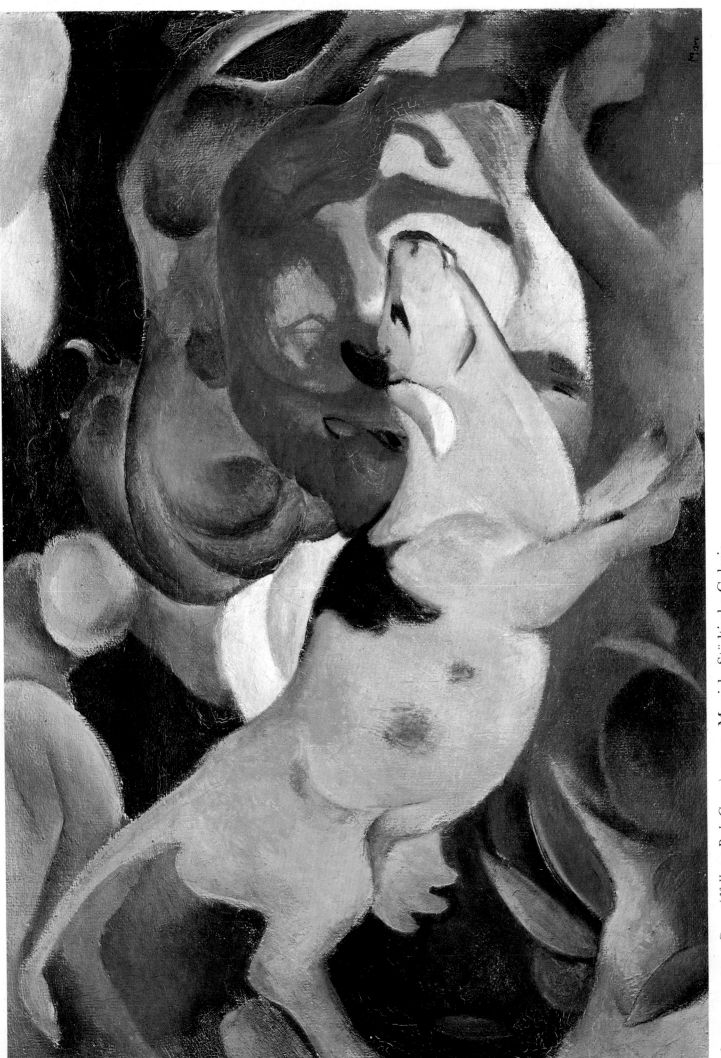

26. FRANZ MARC: *Cows (Yellow, Red, Green)*. 1912. Munich, Städtische Galerie

resurrection and the Last Judgement (Plate 6). Some of the other members of the *Neue Künstler-Vereinigung* found both his subject-matter and his manner of painting uncongenial. They expressed their disapproval in unambiguous terms. Kandinsky had included one of his eschatological paintings, *Composition 5*, among the pictures he proposed to show at the association's third exhibition in December 1911. Each member was allowed to show a number of pictures 'jury free'; but *Composition 5* was too large to escape trial by jury. The picture was brought before the committee and, after a long dispute, was rejected. The president, Adolf Erbslöh, declared it to be not a painting at all, but an object of applied art. At this point, Kandinsky, Marc and Münter announced their resignation and left. 'Well, gentlemen', observed Werefkin, disgusted by this treatment of the society's most active members, 'soon we'll all be wearing nightcaps!'

Kandinsky and Marc were, in fact, prepared for such an eventuality. They had already entered into negotiations with Thannhauser, who agreed to put part of his gallery aside for their use, immediately next to the rooms in which the third exhibition of the *Neue Künstler-Vereinigung* was to take place. In extreme haste, they began assembling a collection of paintings to form the 'First Exhibition of the Editors of the *Blue Rider*'. The two rival exhibitions ran concurrently, the Blue Rider show including works by Macke, Campendonk, Albert Bloch, the brothers Burlyuk, Delaunay, Elizabeth Epstein, Arnold Schoenberg and Henri Rousseau, as well as by Kandinsky, Marc and Münter. There was no jury; Kandinsky and Marc simply selected works in what the former described as a 'purely dictatorial manner'. In the foreword to the catalogue, Kandinsky wrote: 'In this small exhibition, we do not seek to advertise any one precise tendency, but rather the multiplicity of ways in which the spirit is made manifest'. Most of the paintings subsequently travelled to Moscow, where they formed the core of the second 'Jack of Diamonds' exhibition, which opened at the end of January 1912. Meanwhile, the editors of the Almanac were busy preparing a far more ambitious show, consisting entirely of graphic works, to be held in Munich at the Hans Goltz gallery in the spring of 1912. The first Blue Rider exhibition had been a small-scale affair, the selection of paintings reflecting the organizers' personal tastes and friendships. The second exhibition was conceived as a review of contemporary European tendencies in the graphic arts. Apart from friends like Klee and Kubin (neither of whom was represented in the first exhibition), it embraced such diverse artists as Picasso, Heckel and Natalya Goncharova. Of Kandinsky's friends, only Jawlensky and Werefkin were missing; although often classed as Blue Riders, they had in fact remained members of the *Neue Künstler-Vereinigung* after the split within that organization. Their works were, on the other hand, shown at the Blue Rider exhibition organized by Herwarth Walden in Berlin in 1913.

The casual visitor must have been bewildered by the variety of work included in the second Blue Rider show. It should, however, be remembered that this was not a group show in any normal sense. Indeed, there was no group, if by 'group' one means an association having a common manifesto or programme. 'In reality', Kandinsky recalled, 'there was never a society . . . called the "Blue Rider". Marc and I simply took what we wanted, choosing with complete freedom, without worrying about anyone else's views or wishes.' The criteria for including works in the exhibitions were the same as those which governed the selection of illustrations for the Almanac. Kandinsky, in his essay 'Ueber die

Formfrage', wrote: 'The question of form does not in principle exist.' By this he meant that the different styles and 'isms' of modern art were ultimately irrelevant; the true characteristic of the age was an identity of inner striving, rather than any external similarity. He even felt entitled to equate Rousseau's 'greater realism' with his own 'greater abstraction', believing their inner purpose to be fundamentally the same.

It is this lack of external cohesion which makes it almost impossible to speak of a 'Blue Rider style'. Even the works of those artists immediately associated with the Almanac – Münter, Kandinsky, Marc, Macke – are visually quite dissimilar. Münter's paintings are lyrical and uncomplicated; throughout her long life, her art remained firmly rooted in the world of natural appearances. Kandinsky's work of the Blue Rider period is highly abstracted, and of a deeply religious, even mystical, significance. 'Art', he wrote, 'resembles religion in many respects.' Abstraction, and mysticism, remained essentially foreign to both Marc and Macke. Marc's aim was what he called the 'animalization of art', rendering nature as perceived through animals' eyes, in an attempt to see beyond the Schopenhauerian chain of cause and effect which governs our everyday view of the world. 'In Schopenhauer's terms', wrote Marc, 'the world as Will today takes precedence over the world as Representation.' Macke was more interested in colour theory. His paintings, often built up of little blocks and facets of pure colour (Plates 20 and 21), seem closer to the colourful variety of Cubism practised by Delaunay and the Orphists (Plates 43–5, 48), sometimes verging on the purely abstract, but always retaining a representational basis. Macke was also close to Klee, whom he accompanied on a visit to Tunisia in the spring of 1914. The paintings and watercolours they brought back not only serve as a record of the places they visited and the experiences they shared; they also reveal their utterly different temperaments. Macke was captivated by the North African sun, by light and colour (Plate 23). Klee, although he recognized this African experience as a turning-point in his own development as a colourist, was more interested in the dynamic possibilities of line. Paradoxically, it was Klee, no less than Macke, who formed a link between the Munich artists and the Parisian Orphists; he visited Delaunay in Paris in 1912, and translated the French artist's essay 'On Light', which appeared in German in Herwarth Walden's periodical *Der Sturm* in January 1913.

The name 'Blue Rider' should not, then, be construed as a stylistic definition or label. It recalls rather a community of interests, a certain unanimity of approach, and the friendships which united these different personalities. Kandinsky, Marc and Macke all shared, for example, the same delight in colour, which they used in a playful, at times highly sensuous way. Their attitude to colour distinguishes them from their contemporaries, the artists of the *Brücke* (Kirchner (see Plate 47), Heckel, Karl Schmidt-Rottluff, Max Pechstein). The *Brücke* painters had progressed from their own exaggerated version of Fauvism to a more sombre, brutal manner of painting in their works of the years immediately preceding the First World War. Their attitude to life was very different as well – so different that it is hard to understand how both the Blue Riders and the *Brücke* artists have come to be considered as Expressionists. Not without reason, the critic Paul Fechter, in his book *Expressionismus* of 1914, distinguished between what he saw as two completely different kinds of Expressionism: *extensive* Expressionism, which manifested a heightened relationship between the artist and the external world, and *intensive*

10

Expressionism, which concerned itself primarily with expressing the artist's inner self. Fechter regarded Pechstein as a perfect example of the former tendency, Kandinsky as the outstanding representative of the latter. The difference can also be expressed in more strictly philosophical terms. The *Brücke* artists, especially Kirchner and Heckel, were Nietzscheans (as one of Kirchner's earliest commentators, Botho Gräf, was quick to point out). They were convinced of the elemental power of art, using images to communicate a heightened consciousness of reality. The Blue Riders, on the other hand, were Schopenhauerians; they equated the artist's own inner experience with that mysterious reality which lay beyond the mere surface appearance of things. Their works are correspondingly gentle, reticent, and ambiguous. Kandinsky wrote:

> To speak of mystery in terms of mystery.
> Is that not content?
> Is that not the conscious or unconscious *purpose* of the compulsive urge to create?

KANDINSKY: *Woodcut from 'Klänge'*

Outline Biographies

KANDINSKY, Vasily
b. Moscow 1866; d. Paris 1944

One of the leading representatives of abstract art in the twentieth century; an inveterate organizer, who helped found the exhibiting society *Phalanx* (Munich, 1901) and the *New Artists' Association of Munich* (1909), and·who was responsible, with Franz Marc, for publishing the Almanac *Der Blaue Reiter* (Munich, 1912). At the outbreak of war in 1914 he left Germany for Switzerland, returning later to Russia, where he was active for a period after the Revolution in the field of art education and the reorganization of museums. In 1921 he returned to Germany, and the following year he was invited by Walter Gropius to take up a professorship at the Bauhaus, a post he held until the closure of that institute in 1933. Certain ideals of the Blue Rider period were revived by Kandinsky, together with Alexei von Jawlensky, Paul Klee and Lyonel Feininger, who founded the group *Die Blauen Vier* (The Blue Four). In 1933 Kandinsky emigrated to France, and spent his last years in Paris, being granted French nationality in 1939. His writings include the treatises *On the Spiritual in Art* (1912) and *Point and Line to Plane* (1926).

MARC, Franz
b. Munich 1880; d. Verdun 1916

Co-editor, with Kandinsky, of the Almanac *Der Blaue Reiter*. His friendship not only with Kandinsky but also with the painter August Macke and the collector Bernhard Koehler brought him into the forefront of *avant-garde* painting in Germany. A brilliant writer who shared Kandinsky's interest in philosophy, his essays include the important article 'The German "Fauves"' published in the *Blue Rider*. His paintings of the Blue Rider period combine a range of subject-matter based on animal themes with a lyrical colourism in which the influence of Robert Delaunay is perceptible. His paintings formed an important contribution to the two Blue Rider exhibitions, and to Herwarth Walden's *Erster Deutscher Herbstsalon* (Berlin, 1913). The drawings he made during military service were later collected under the title *Sketches from the Field*.

MACKE, August
b. Meschede 1887; d. Perthes 1914

A student both of the Academy and of the School of Applied Arts in Düsseldorf, Macke was influenced both by French painting and by the German Impressionism of Lovis Corinth. He made two important visits to Paris, in 1907 and 1908; his friendship with Marc dated from the beginning of 1910. Initially somewhat suspicious of Kandinsky's mystical tendencies, he later became closely associated with plans for the publication of

the *Blue Rider Almanac*, contributing the essay 'Masks'. In September 1912, with Marc, he visited Delaunay in Paris, and went to North Africa in the spring of 1914, in the company of Klee and Louis Moilliet. He was killed in action during the first days of the Great War.

MÜNTER, Gabriele
b. Berlin 1877; d. Murnau 1962

Initially a student of the Munich *Jugendstil* artist Angelo Jank, Münter transferred in 1902 to the painting school of the *Phalanx*, where she met Kandinsky. She accompanied him on his travels throughout Europe, 1904–8, and was a co-founder of the *New Artists' Association of Munich*, from which she resigned, together with Kandinsky and Marc, in December 1911. She contributed works to both Blue Rider exhibitions and also to the *Erster Deutscher Herbstsalon*. Her relationship with Kandinsky ended with his return to Moscow in 1916. In 1957, on her eightieth birthday, she bequeathed many works, mainly by herself and Kandinsky, to the city of Munich.

JAWLENSKY, Alexei von (Alexei Yavlensky)
b. Kuslovo, Tver 1864; d. Wiesbaden 1941

Originally destined for a military career, Jawlensky studied under Ilya Repin at the St Petersburg Academy. His friendship with Marianne von Werefkin (Mariamne Verefkina) began in his student days; in 1896 they left Russia to study painting in Munich under Anton Azbé. Jawlensky was vice-president of the *New Artists' Association*, and his work was represented at the Blue Rider exhibition organized by Herwarth Walden in Berlin in 1913. In 1924 he joined Kandinsky, Klee and Feininger to form the group *The Blue Four*.

KLEE, Paul
b. Münchenbuchsee 1879; d. Muralto 1940

Like Kandinsky, Klee was for a time a student of Franz von Stuck at the Munich Academy. His early work, in which prints and drawings are dominant, is partially influenced by the paintings of his compatriot Ferdinand Hodler. Klee came to Munich in 1906, and in 1911 became friendly with the artists of the *Neue Künstler-Vereinigung*. In 1912 he met Delaunay in Paris; in 1914, together with Macke and Moilliet, he visited North Africa, and was a co-founder of the 'New Munich Secession'. From 1921 he was professor at the Bauhaus, and from 1924 a member of the group *The Blue Four*. In 1930 he accepted a professorship at the Düsseldorf Academy. Klee returned to Switzerland in 1933.

Select Bibliography

W. Kandinsky and F. Marc, editors, *The Blaue Reiter Almanac*. New documentary edition edited and with an introduction by Klaus Lankheit. New York/London 1974.

W. Kandinsky, 'Reminiscences', in *Modern Artists on Art*, edited by Robert L. Herbert. Englewood Cliffs 1964.

W. Grohmann, *Kandinsky, Life and Work*. With a *catalogue raisonné* of the artist's paintings. New York/London 1959.

Hans Konrad Roethel, *The Blue Rider*. New York/London 1971.

Hans Konrad Roethel, *Kandinsky, Painting on Glass*. Catalogue of the centenary exhibition held at the Solomon R. Guggenheim Museum. New York 1966.

K. Lankheit, *Franz Marc—Watercolours, Drawings, Writings*. London 1960.

C. Weiler, *Alexej Jawlensky*. Cologne 1959.

P. Klee, *Diaries*. London 1965.

W. Haftmann, *The Mind and Work of Paul Klee*. London 1964.

V. H. Miesel, editor, *Voices of German Expressionism*. Englewood Cliffs 1970. Contains extracts from the *Blue Rider Almanac*, and from the correspondence between Franz Marc and August Macke.

J. Eichner, *Kandinsky und Gabriele Münter—von Ursprüngen moderner Kunst*. Munich [1957].

List of Plates

board, 48 × 67·7 cm. Munich, Städtische Galerie.

38. JAWLENSKY: *Young Girl with Peonies*. 1909. Wuppertal, Van der Heydt Museum.

39. JAWLENSKY: *Spanish Lady*. 1913. Cardboard, 67 × 48·5 cm. Munich, Städtische Galerie.

40. PAUL KLEE (1879–1940): *Abstraction*. 1914. Watercolour, 11·5 × 17 cm. Berne, Paul Klee Foundation.

41. KLEE: *Föhn (South Wind) in Marc's Garden*. 1915. Watercolour, 20 × 15 cm. Munich, Städtische Galerie.

42. KLEE: *Garden Still-Life with Watering Can*. 1910. Watercolour, 13·9 × 13·3 cm. Munich, Städtische Galerie.

43. ROBERT DELAUNAY (1885–1941): *La Ville de Paris*. 1910–12. Canvas, 267 × 406 cm. Paris, Musée d'Art Moderne.

44. DELAUNAY: *Circular Forms, Sun and Tower*. 1913. 110 × 90 cm. Paris, Private Collection.

45. DELAUNAY: *Circular Forms*. 1912–13. Paris, Mme S. Delaunay.

46. NATALYA GONCHAROVA (1881–1962): *Electric Lamps*. 1912. Canvas, 105 × 81 cm. Private Collection.

47. ERNST LUDWIG KIRCHNER (1880–1938): *Self-Portrait with Model*. 1907. Canvas, 150 × 100 cm. Hamburg, Kunsthalle.

48. SONIA DELAUNAY-TERK (b. 1885): *Simultaneous Colours*. 1913. Bielefeld, Städtisches Kunsthaus.

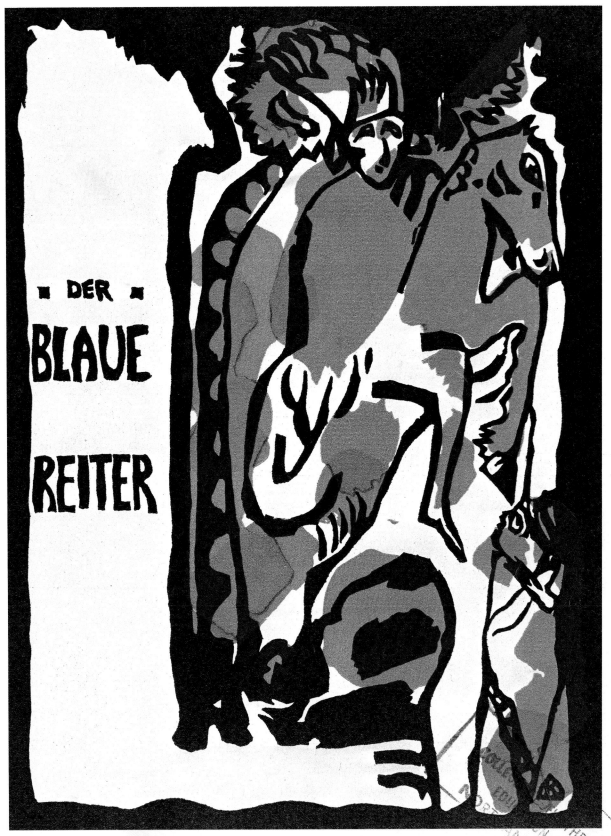

DER BLAUE REITER

1. VASILY KANDINSKY (1866–1944): *Woodcut for the cover of the 'Blue Rider Almanac'.* 1912

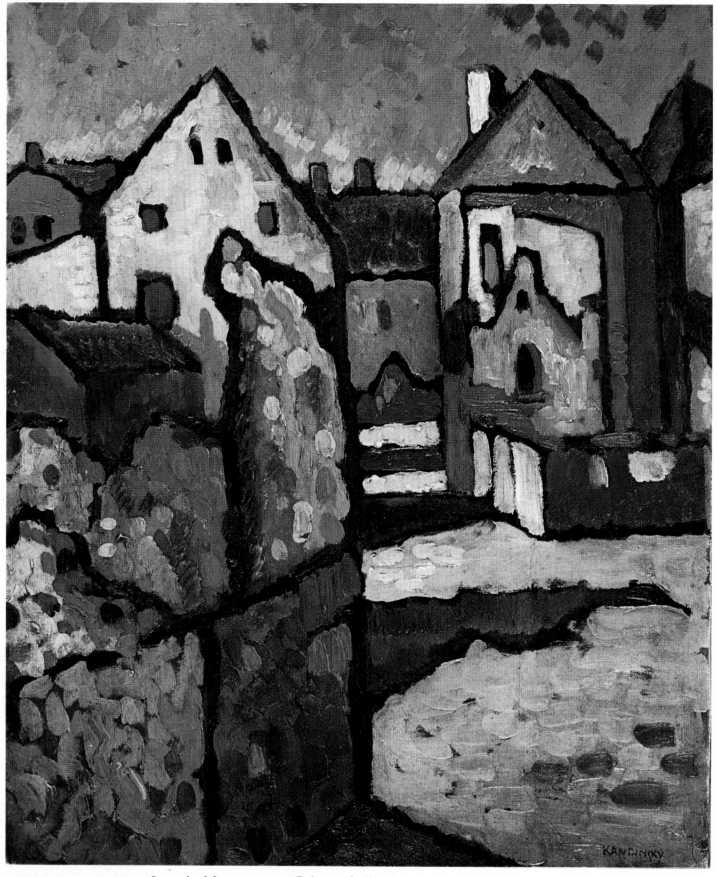

2. VASILY KANDINSKY: *Street in Murnau*. 1909. Private Collection

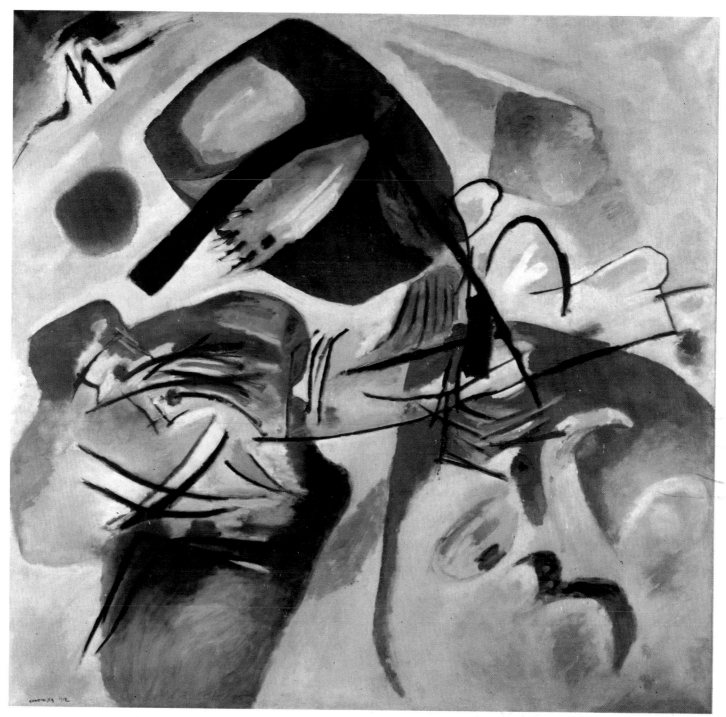

3. VASILY KANDINSKY: *Painting with Black Arch.* 1912. Paris, Musée d'Art Moderne

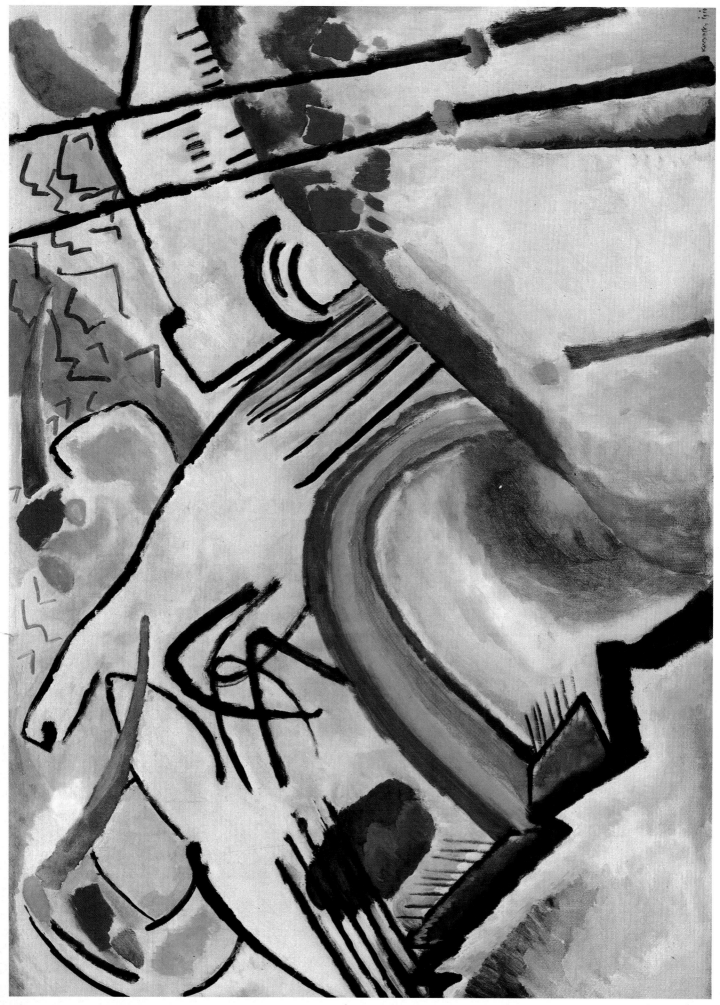

4. VASILY KANDINSKY: *Sketch for Composition IV (Battle)*. 1910. London, Tate Gallery

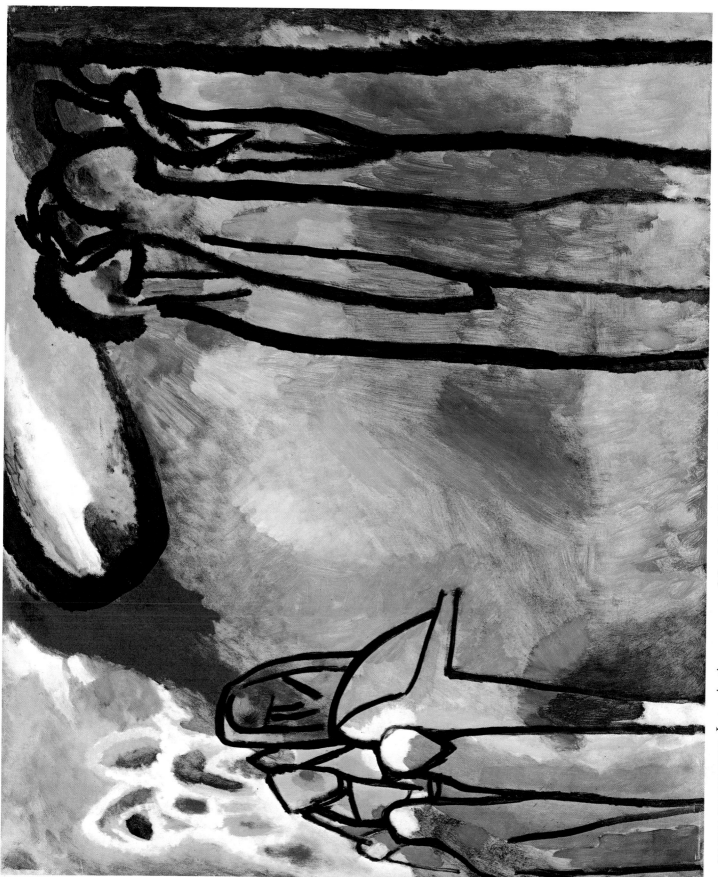

5. VASILY KANDINSKY: *Improvisation 19.* 1911. Munich, Städtische Galerie

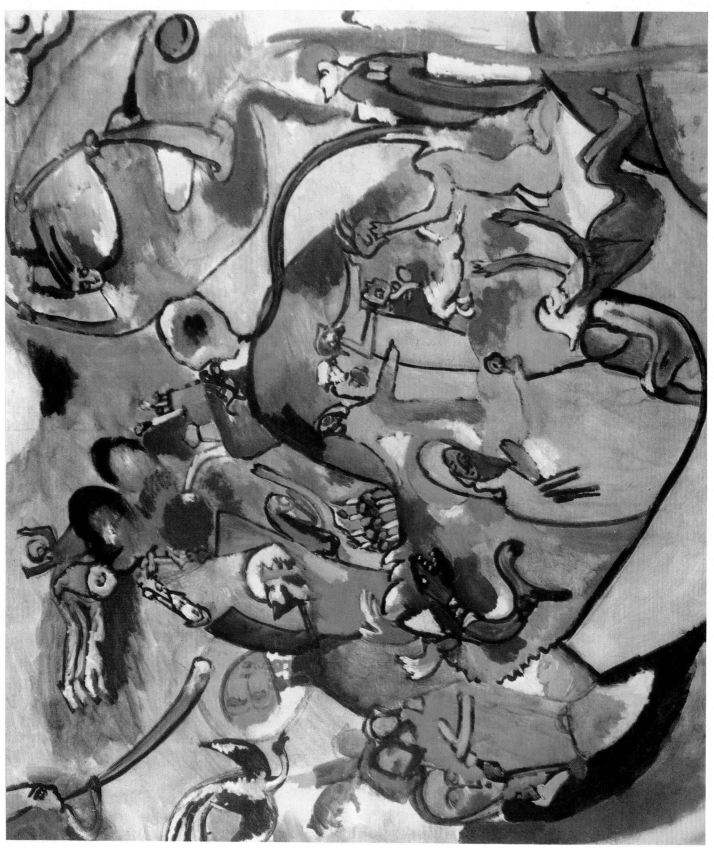

6. VASILY KANDINSKY: *All Saints Day II*. 1911. Munich, Städtische Galerie

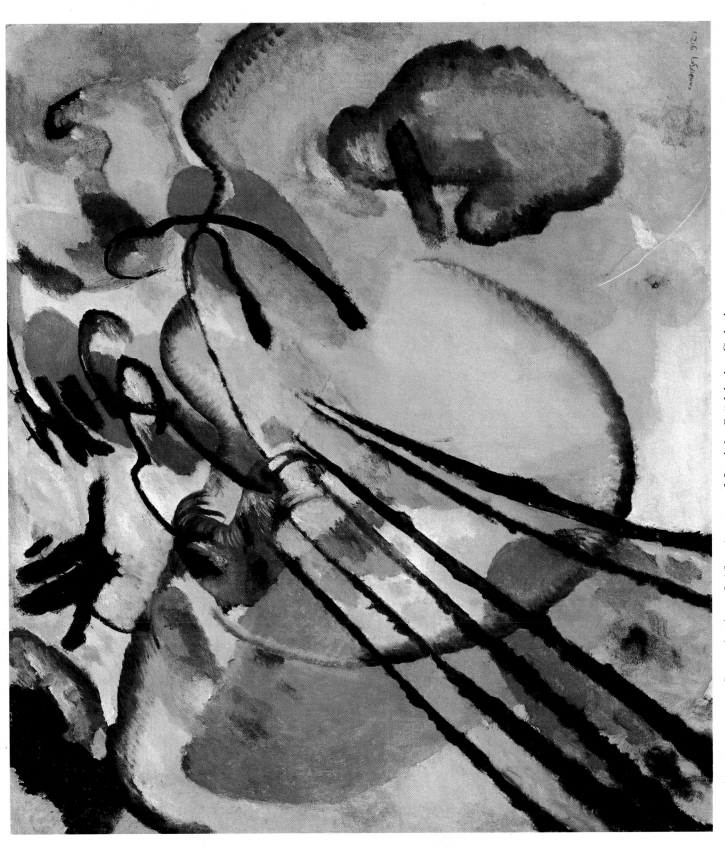

7. VASILY KANDINSKY: *Improvisation 26 (Oars)*. 1912. Munich, Städtische Galerie

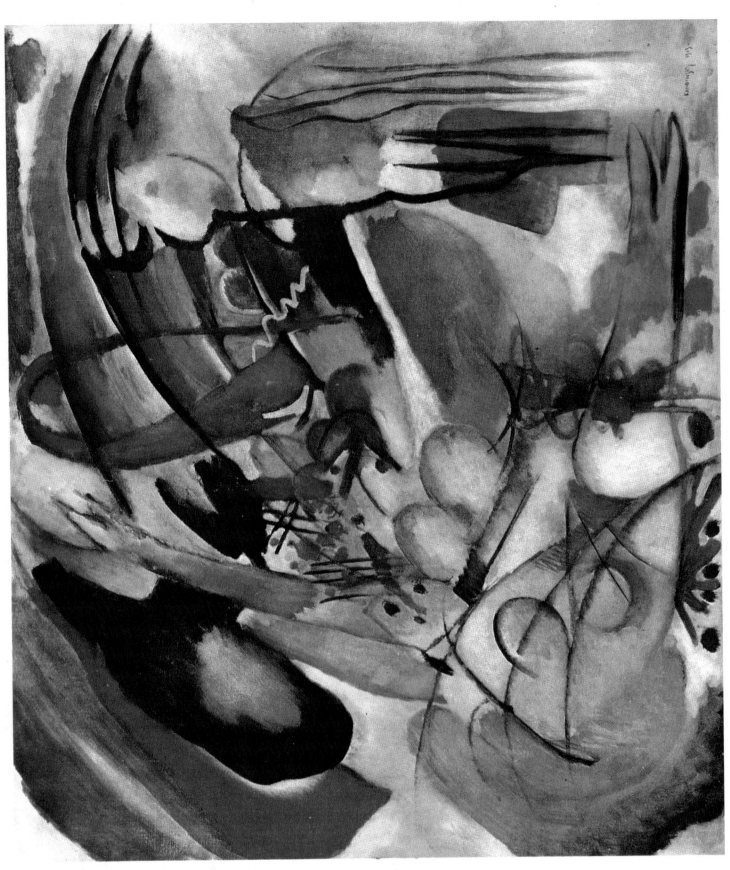

8. VASILY KANDINSKY: *Sketch for 'Orient'*. 1913. Amsterdam, Stedelijk Museum

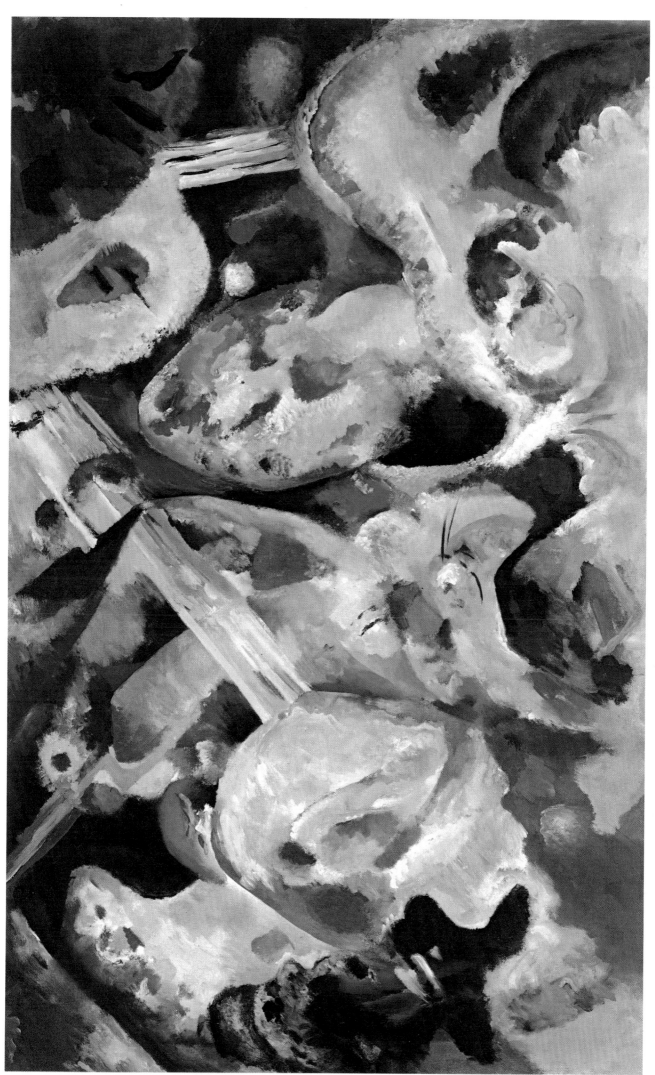

9. VASILY KANDINSKY: *Improvisation (The Flood)*. 1913. Munich, Städtische Galerie

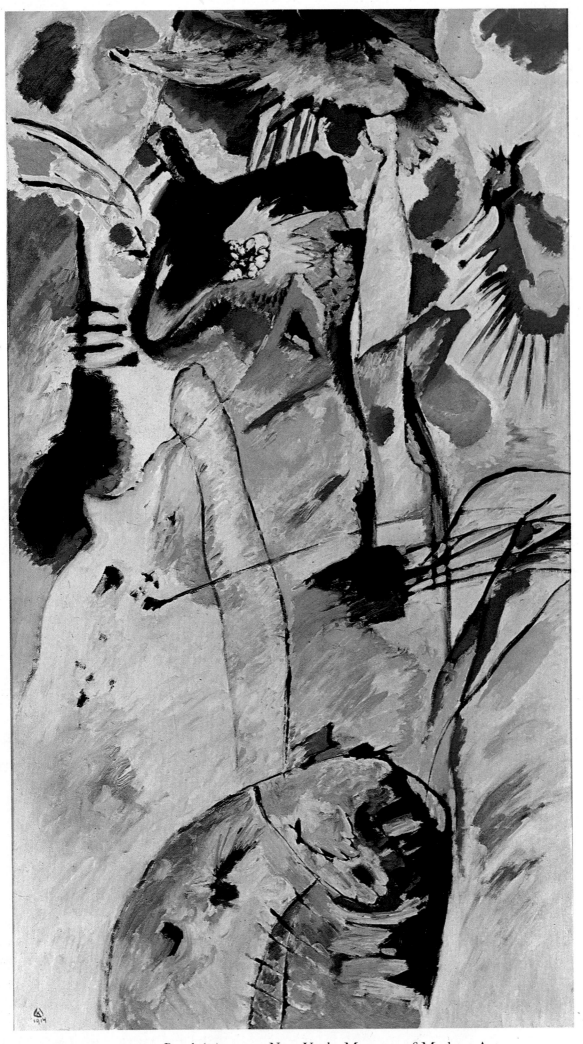

10. VASILY KANDINSKY: *Panel (3)*. 1914. New York, Museum of Modern Art

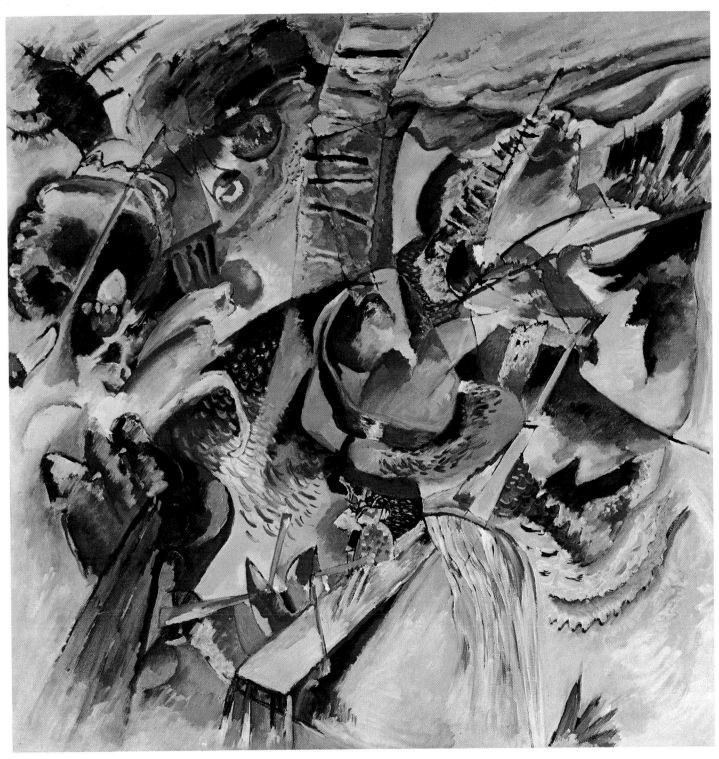

11. VASILY KANDINSKY: *Improvisation 'Gorge'*. 1914. Munich, Städtische Galerie

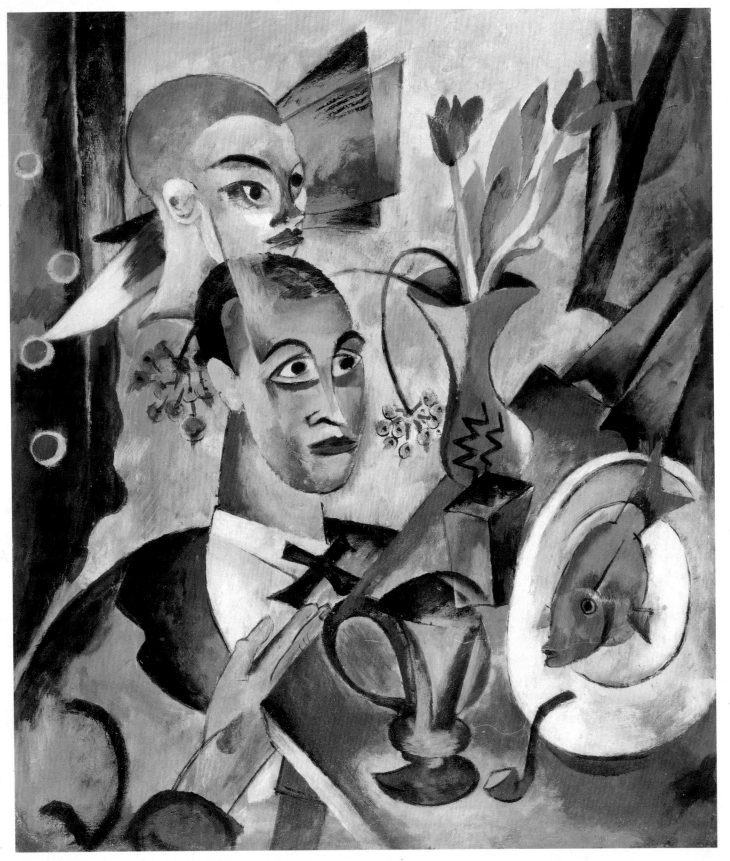

12. HEINRICH CAMPENDONK (1889–1957): *Still-Life with Two Heads*. Bonn, Städtische Kunstsammlungen

13. HEINRICH CAMPENDONK: *Girl Playing a Shawm*. 1914. Munich, Städtische Galeri

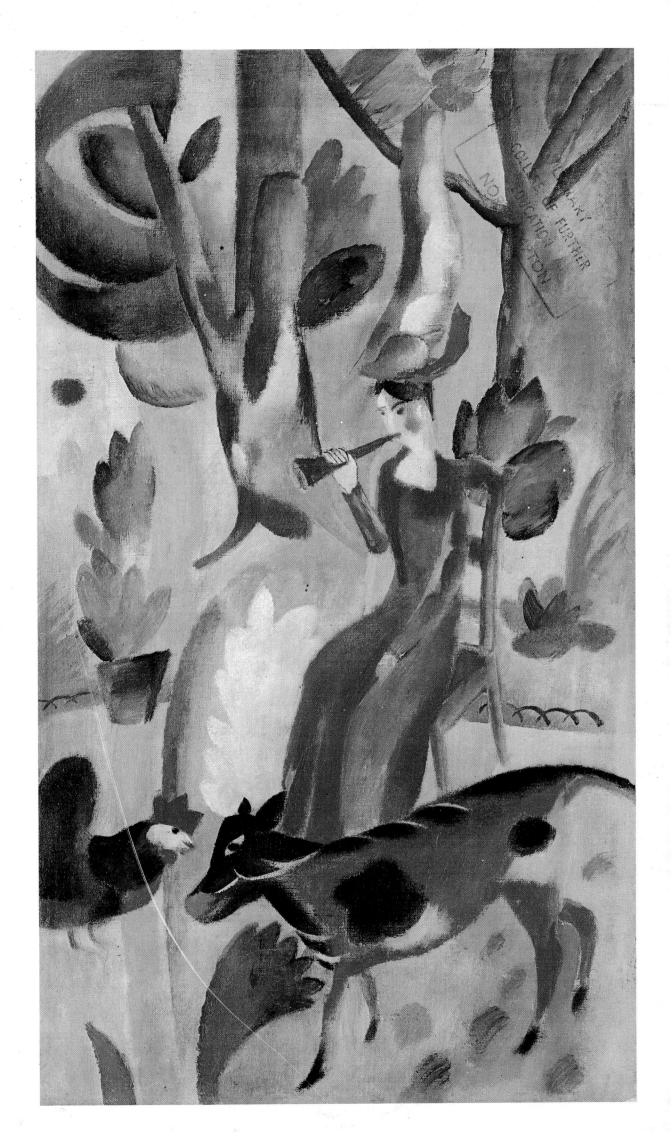

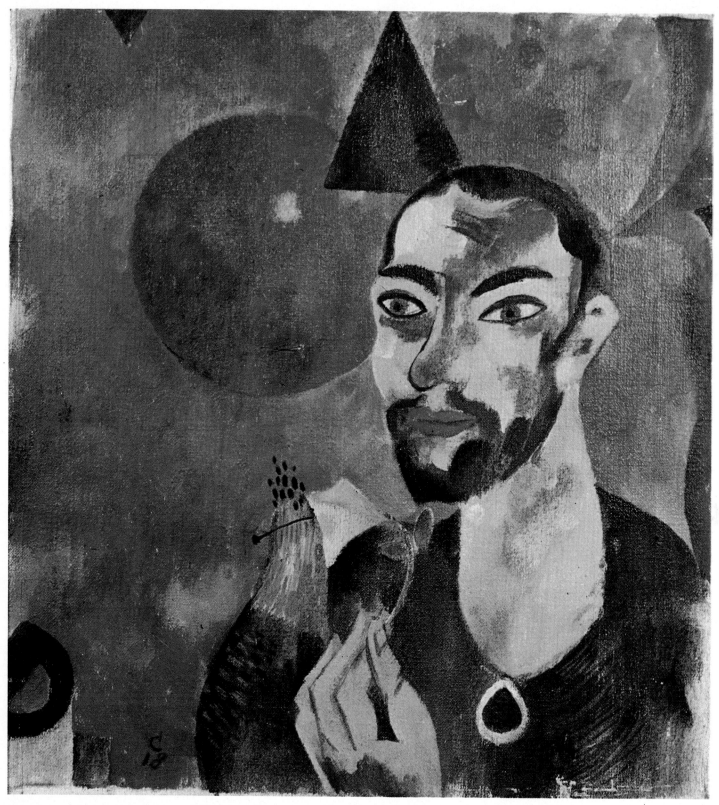

14. HEINRICH CAMPENDONK: *Man with Flower*. 1918. Amsterdam, Stedelijk Museum

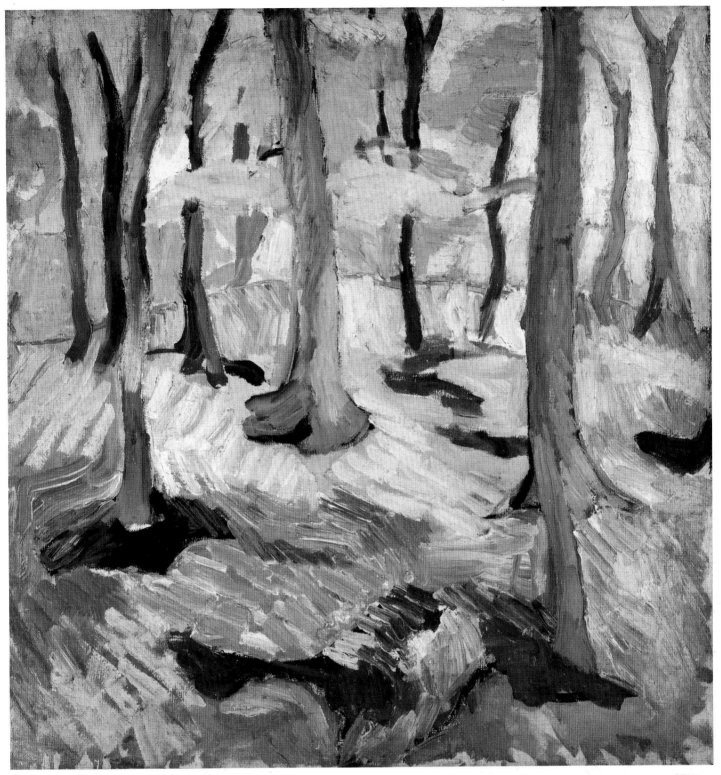

15. AUGUST MACKE (1887–1914): *Wood at Dilborn*. Bonn, Städtische Kunstammlungen

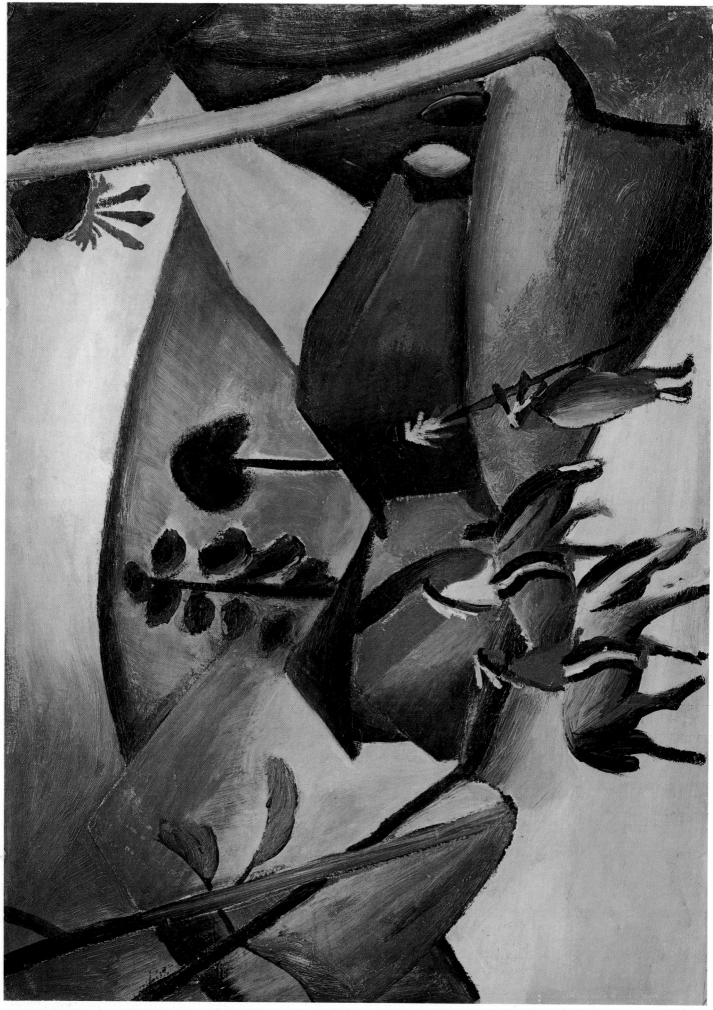

16. AUGUST MACKE: *Indians on Horseback*. 1911. Munich, Städtische Galerie

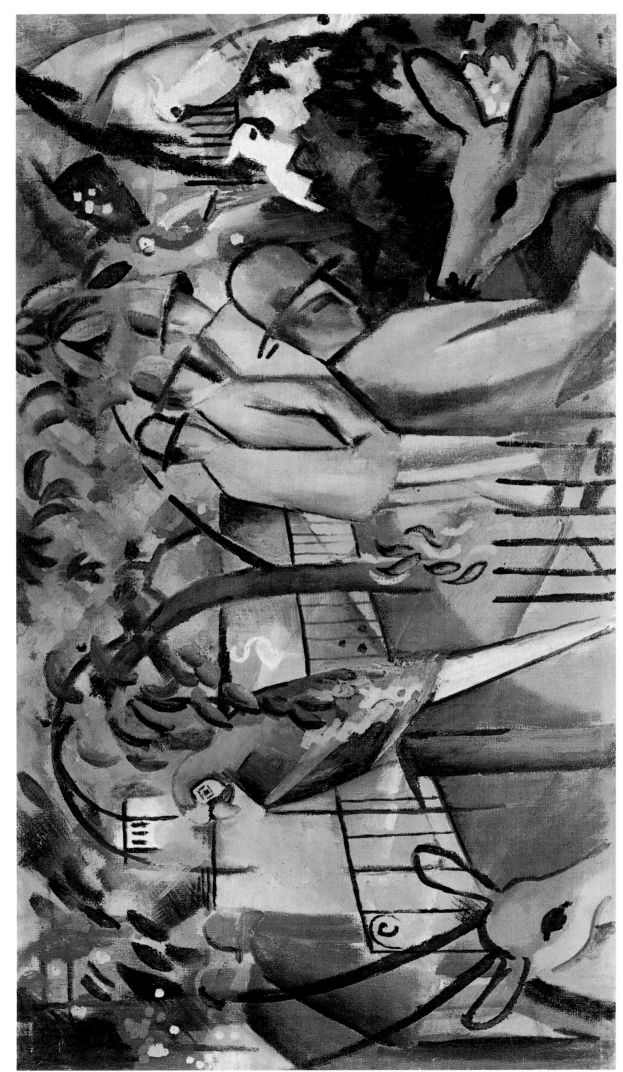

17. AUGUST MACKE: *The Zoo I*. 1912. Munich, Städtische Galerie

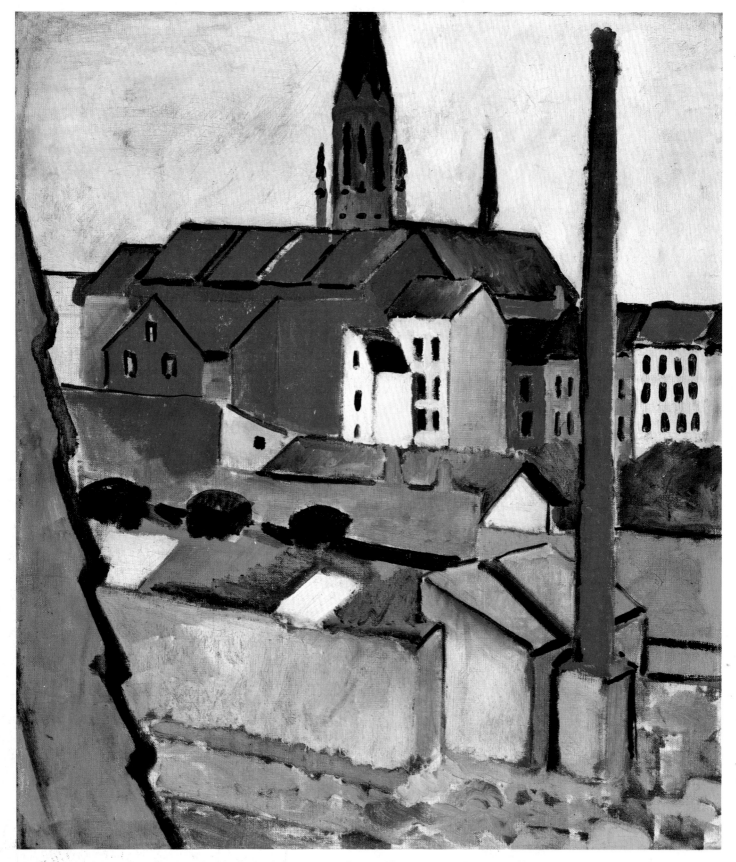

18. AUGUST MACKE: *The Marienkirche in Bonn*. 1911. Bonn, Städtische Kunstsammlungen

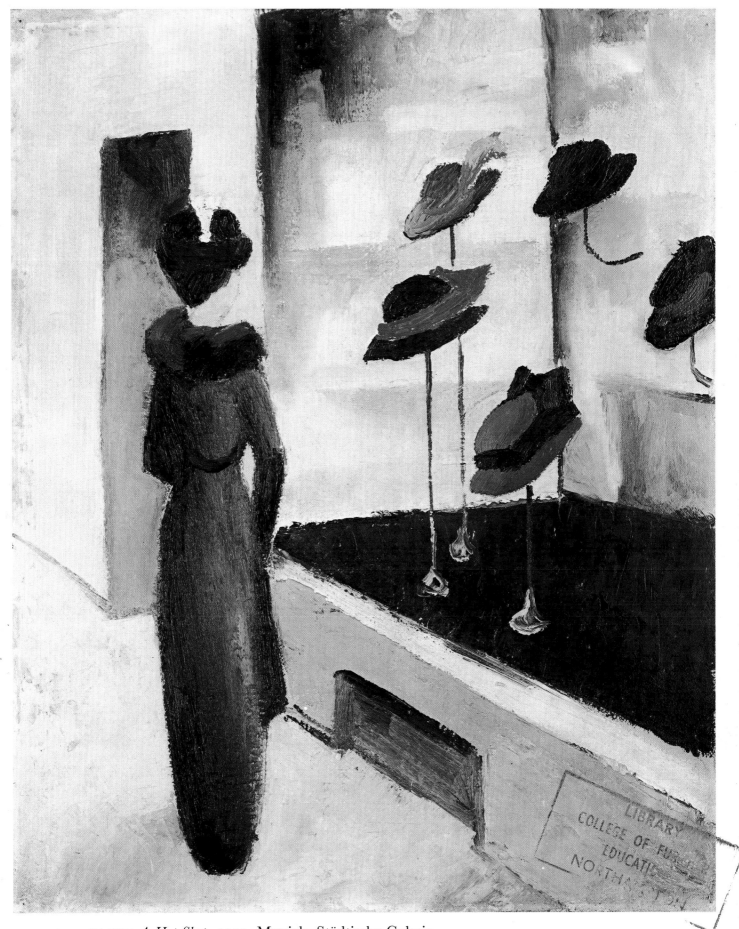

19. AUGUST MACKE: *A Hat Shop*. 1913. Munich, Städtische Galerie

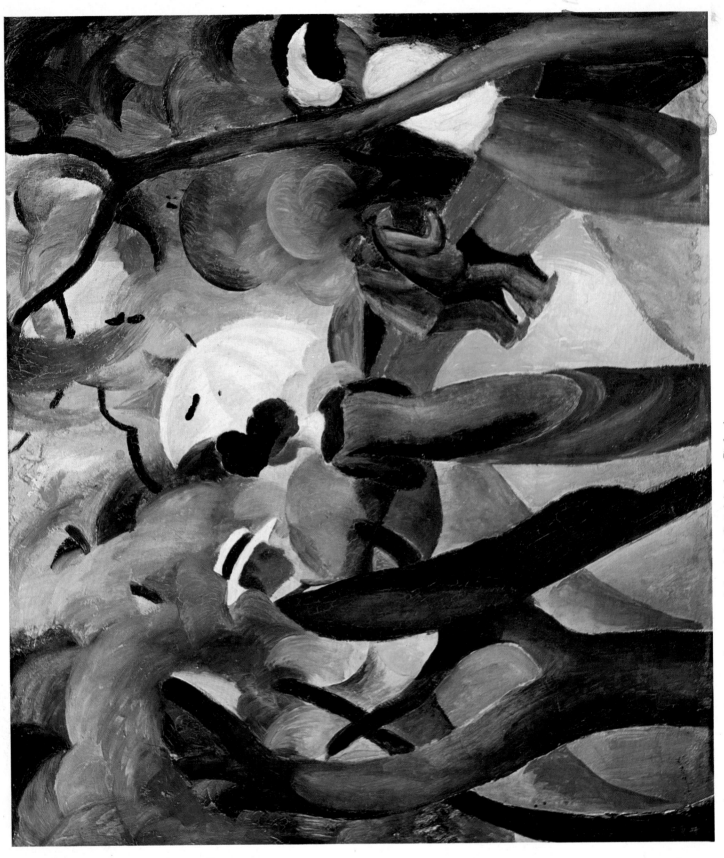

20. AUGUST MACKE: *Promenade*. 1913. Munich, Städtische Galerie

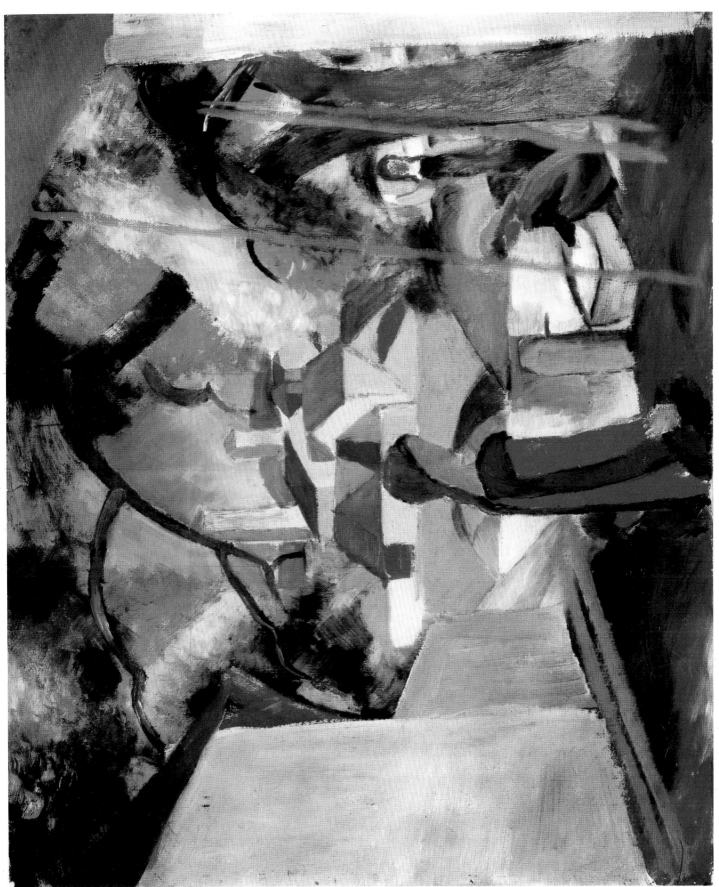

21. AUGUST MACKE: *Children at the Well.* 1914. Bonn, Städtische Kunstsammlungen

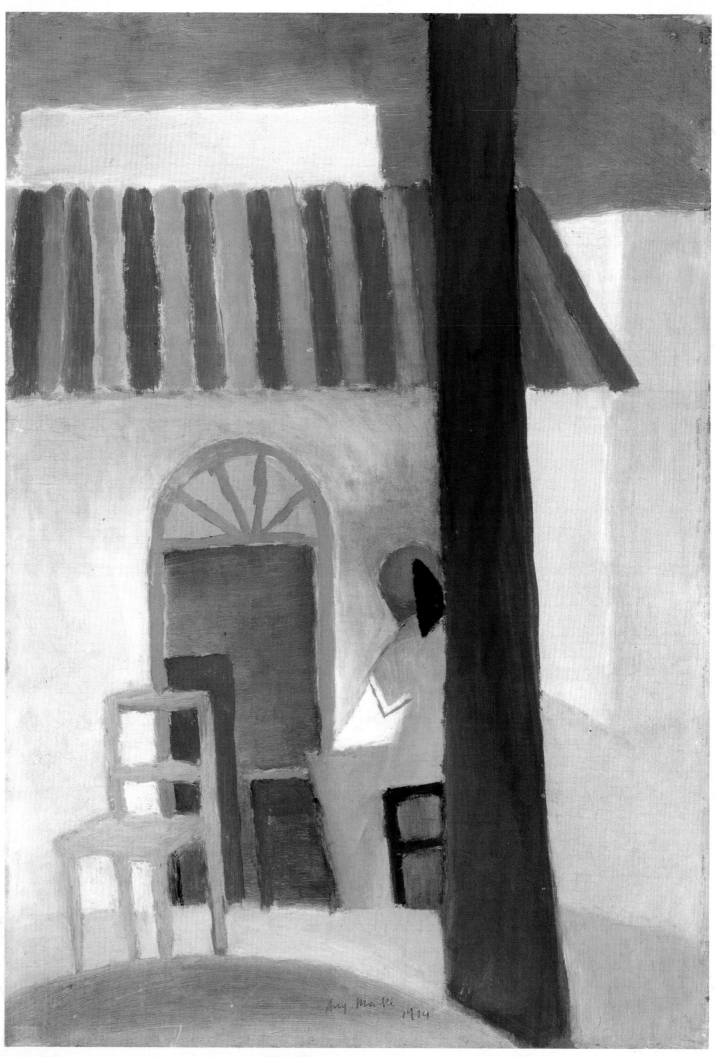

22. AUGUST MACKE: *A Moorish Café.* 1914. Bonn, Städtische Kunstsammlungen

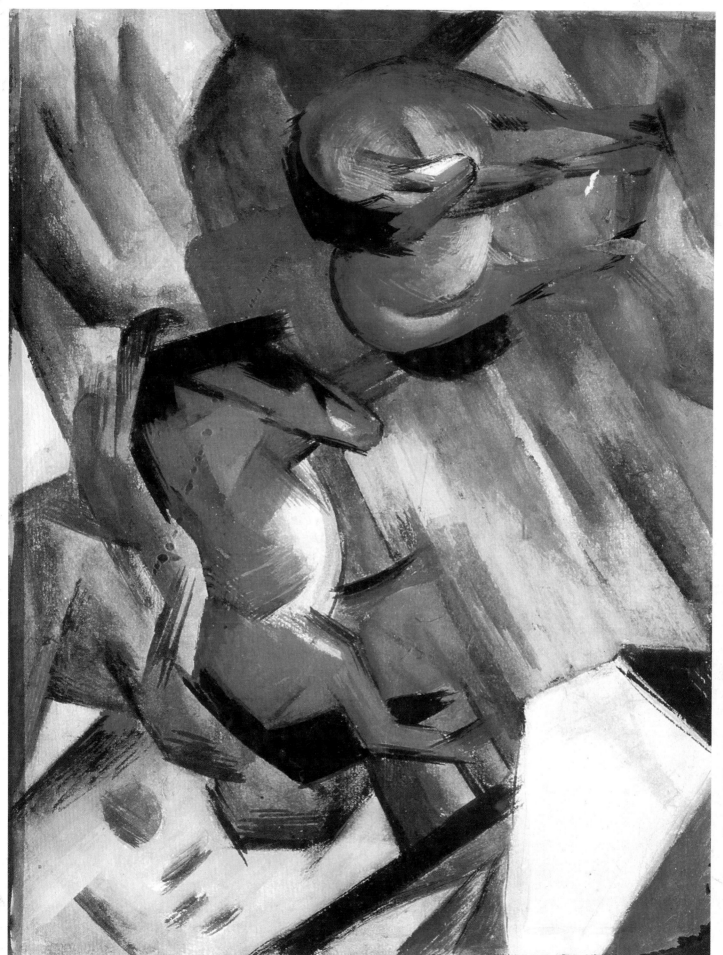

27. FRANZ MARC: *Red and Blue Horses.* 1912. Munich, Städtische Galerie

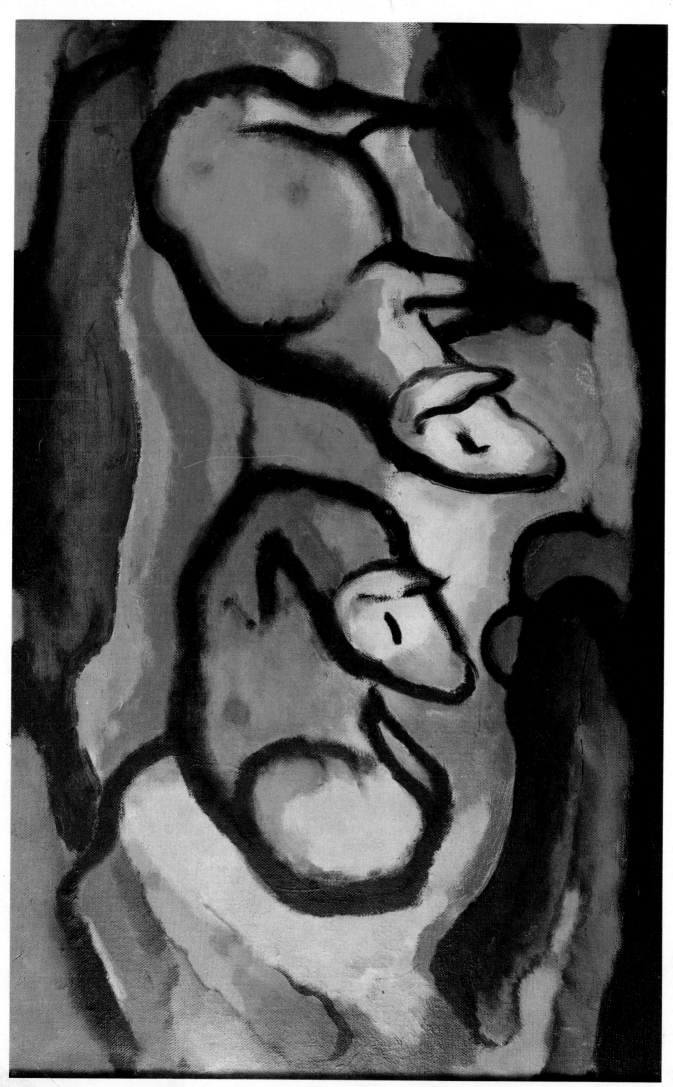

28. FRANZ MARC: *Sheep*. 1912. Saarbrücken, Saarland Museum

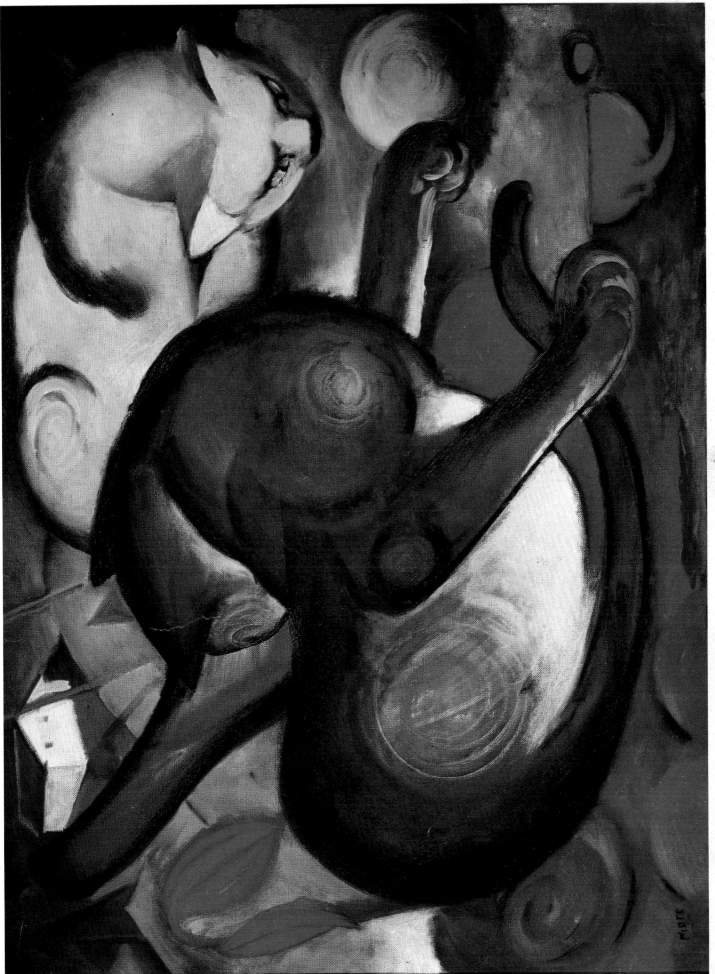

29. FRANZ MARC: *Two Cats*. 1912. Basle, Kunstmuseum

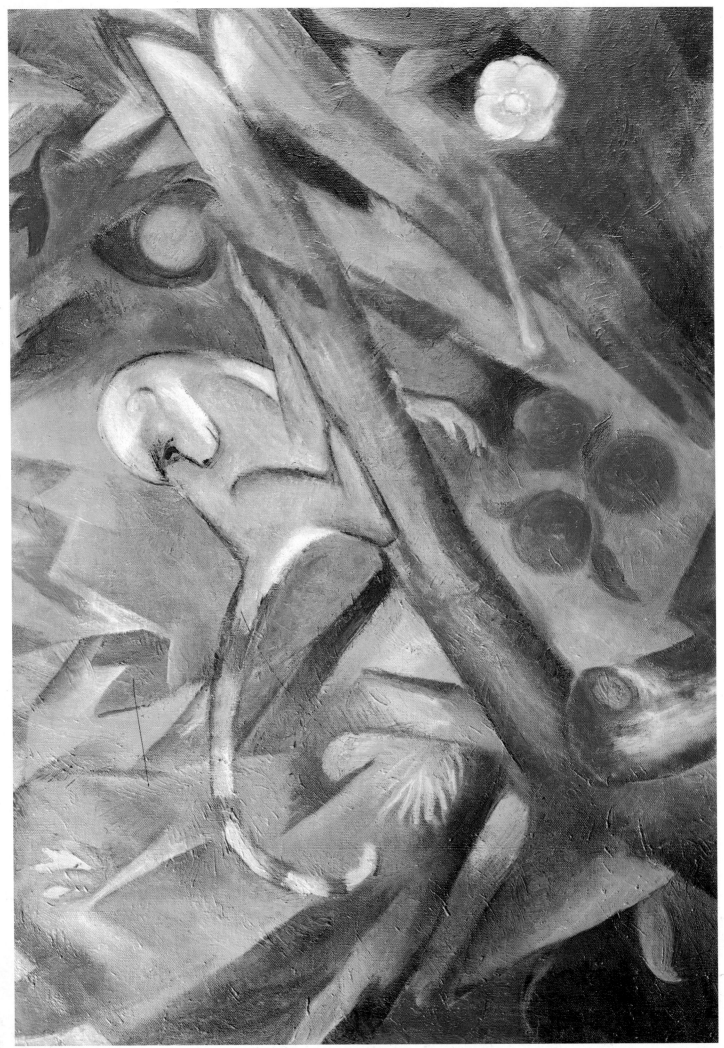

30. FRANZ MARC: *The Little Monkey*. 1912. Private Collection

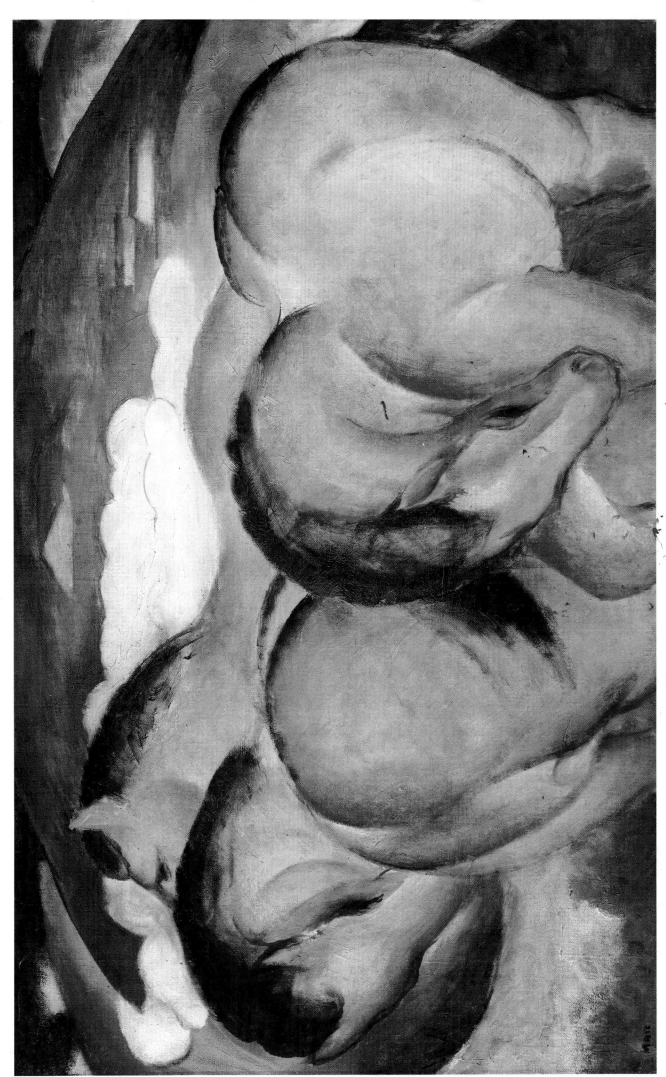

31. FRANZ MARC: *Yellow Horses*. 1912. Stuttgart, Staatsgalerie

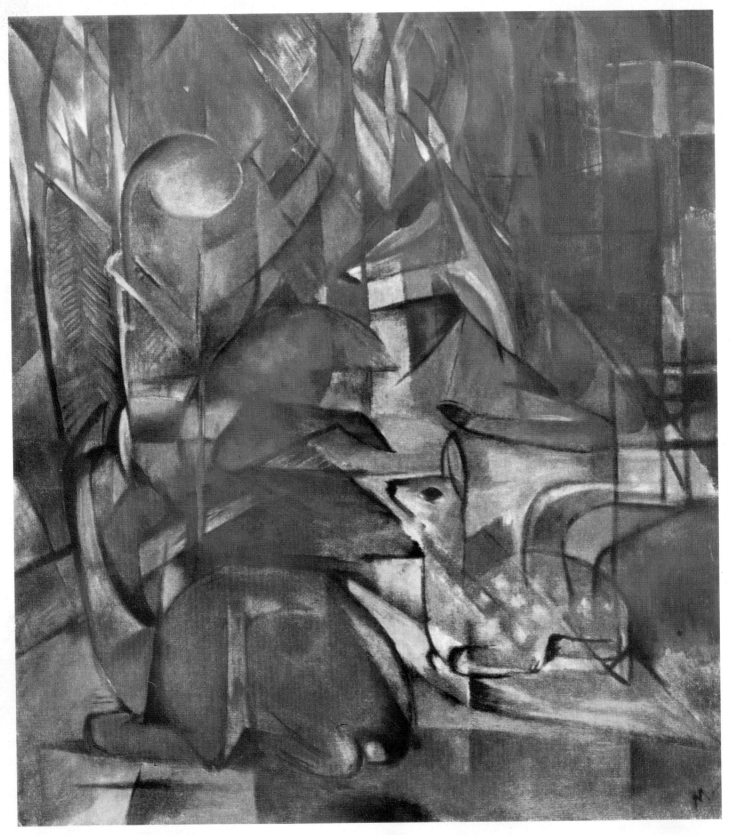

32. FRANZ MARC: *Deer in a Wood II.* 1913–14. Karlsruhe, Staatliche Kunsthalle

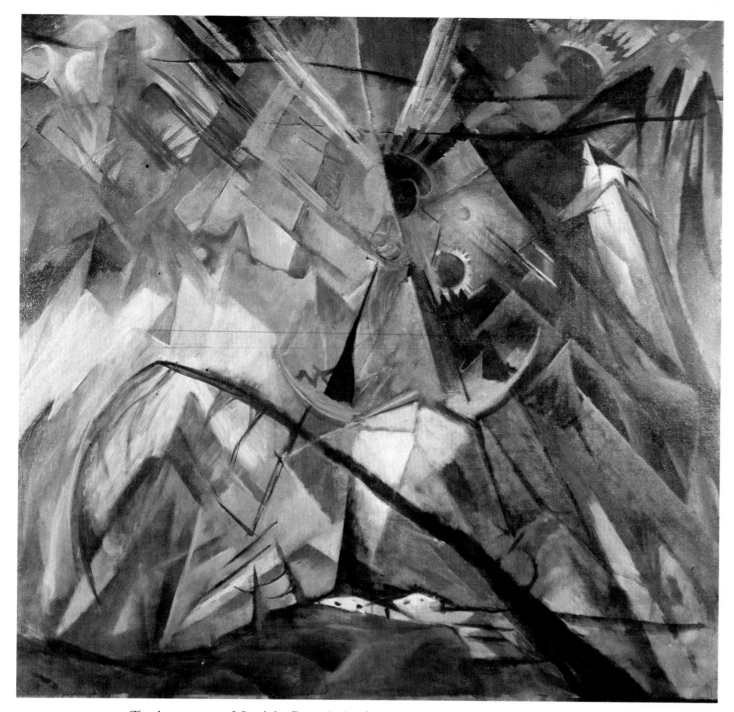

33. FRANZ MARC: *Tyrol.* 1913–14. Munich, Bayerische Staatsgemäldesammlungen

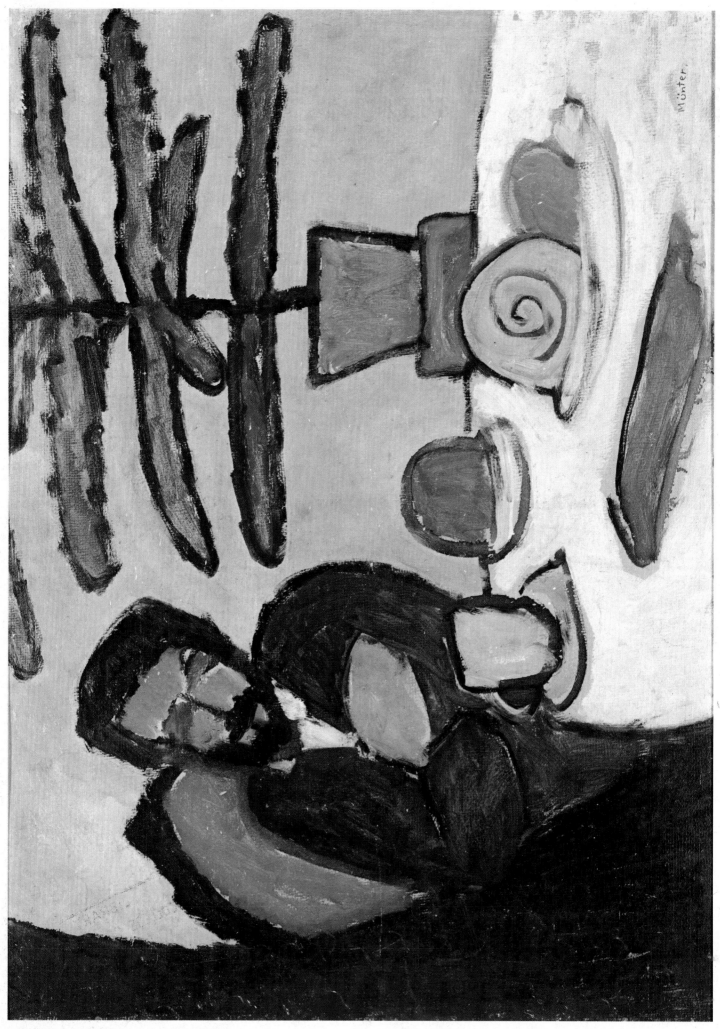

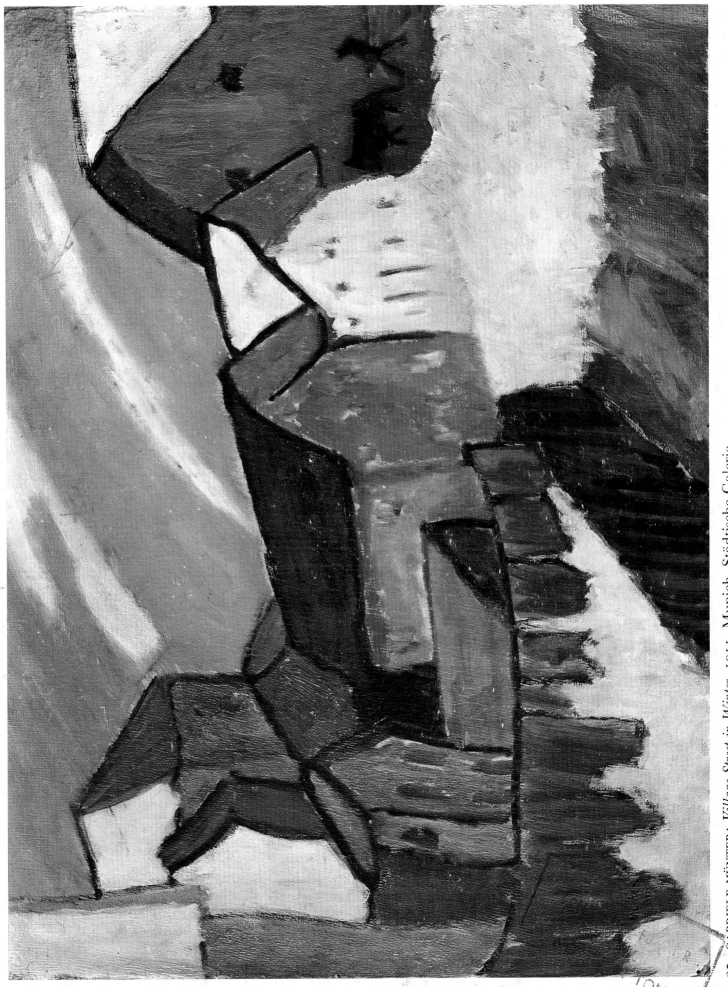

35. GABRIELE MÜNTER: *Village Street in Winter*. 1911. Munich, Städtische Galerie

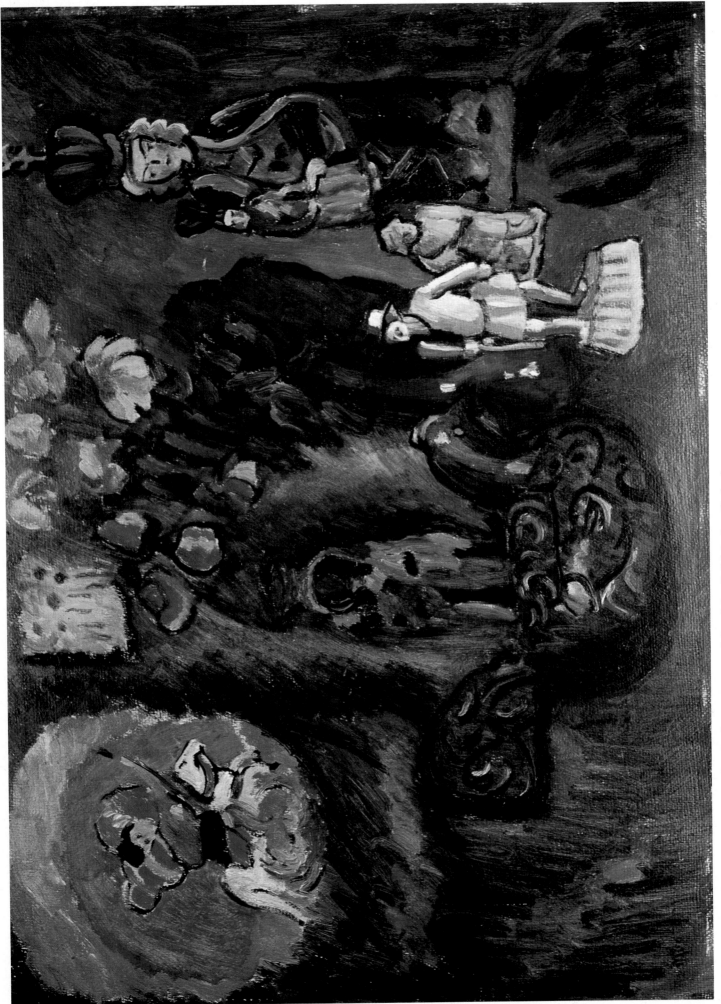

36. GABRIELE MÜNTER: *Still-Life with St George*. 1911. Munich, Städtische Galerie

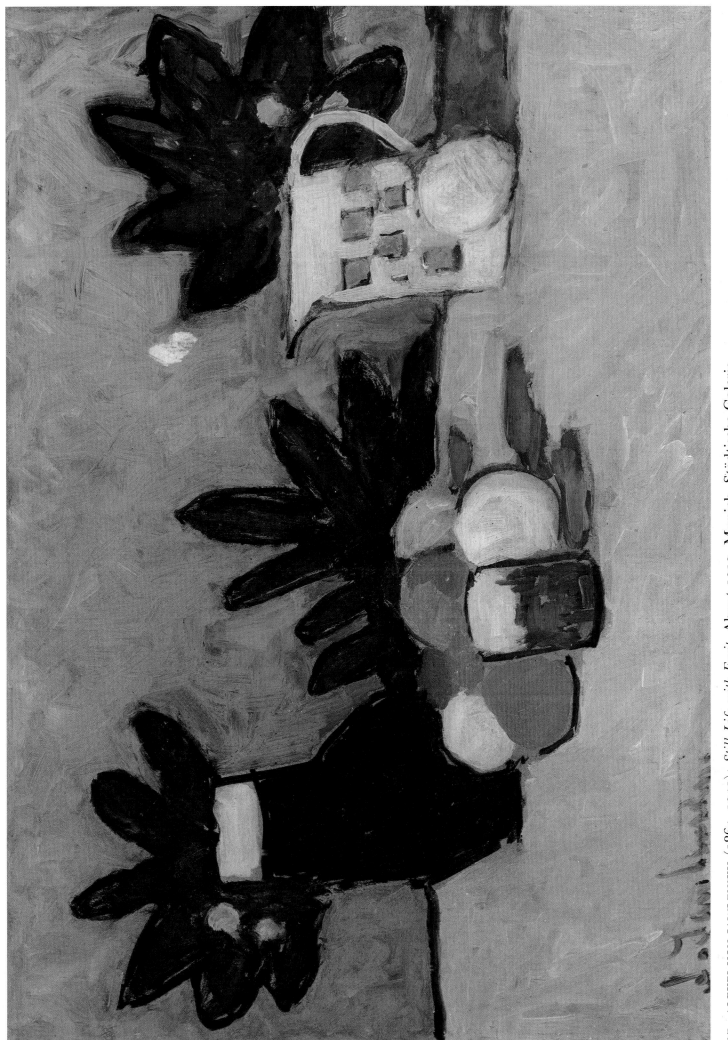

37. ALEXEI VON JAWLENSKY (1864–1941): *Still-Life with Fruit*. About 1910. Munich, Städtische Galerie

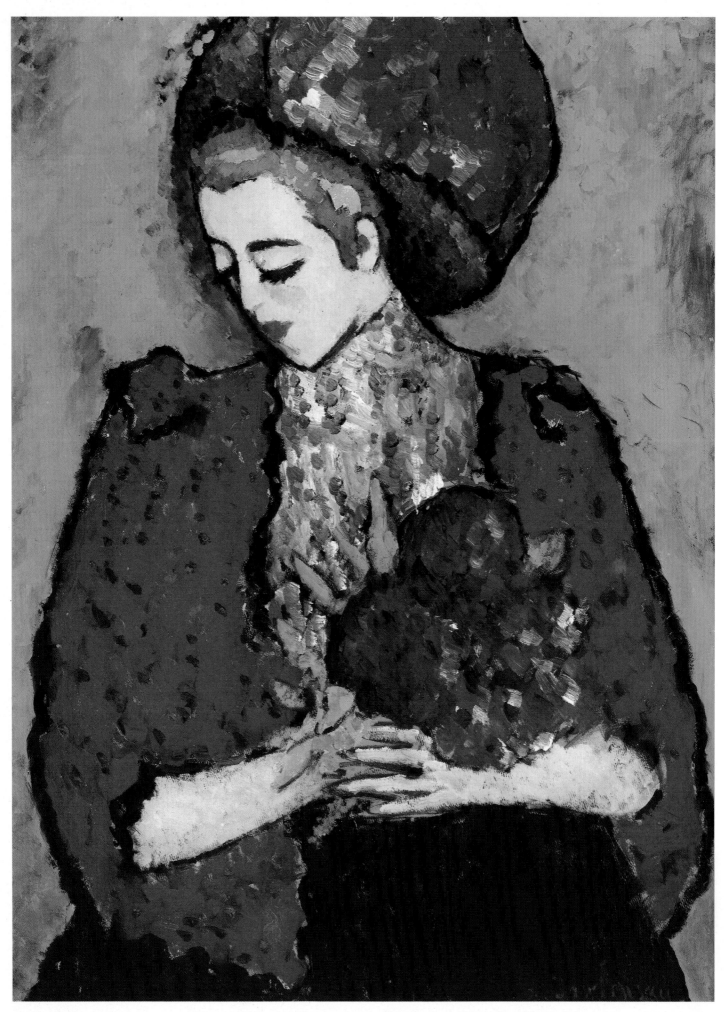

38. ALEXEI VON JAWLENSKY: *Young Girl with Peonies*. 1909. Wuppertal, Van der Heydt Museum

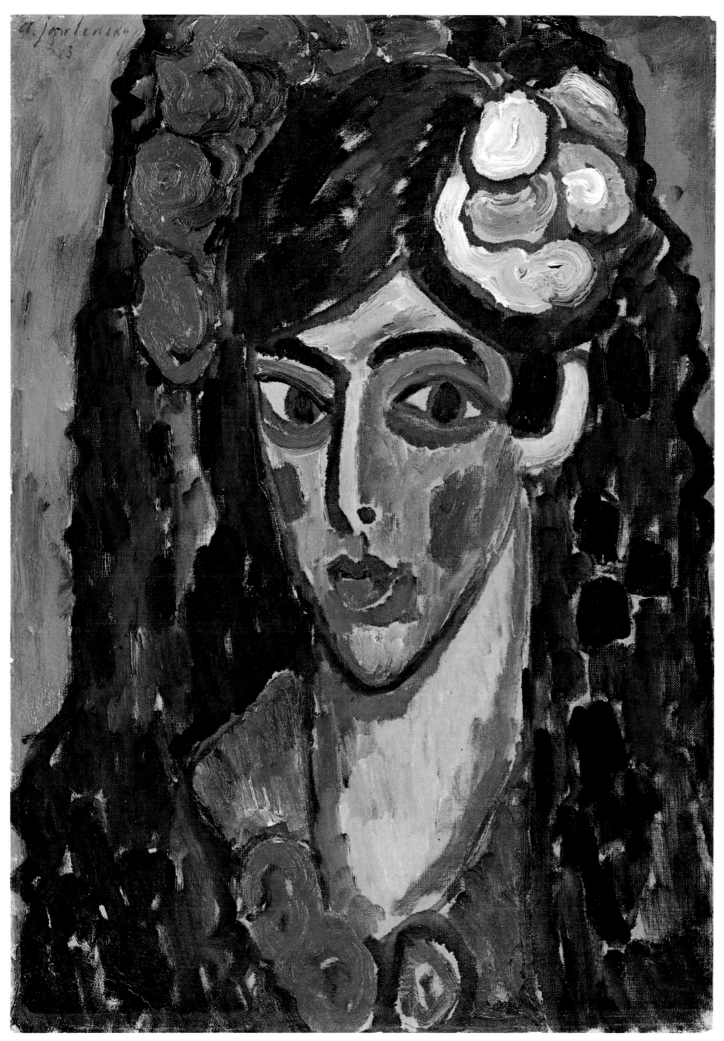

39. ALEXEI VON JAWLENSKY: *Spanish Lady*. 1913. Munich, Städtische Galerie

40. PAUL KLEE (1879–1940): *Abstraction*. 1914. Berne, Paul Klee Foundation

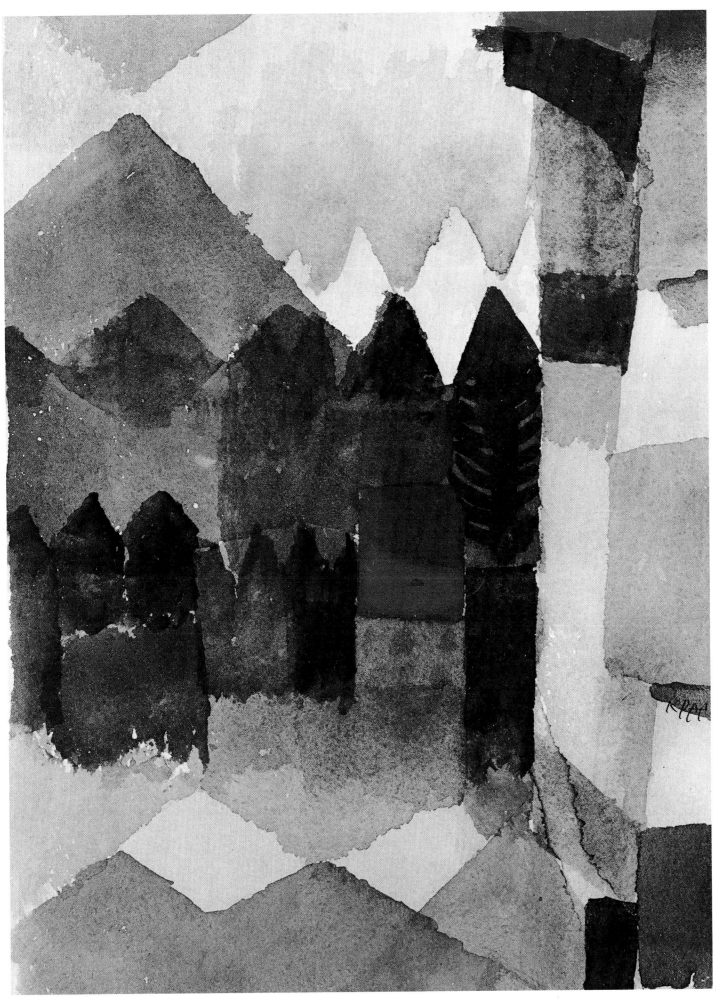

41. PAUL KLEE: *Föhn (South Wind) in Marc's Garden*. 1915. Munich, Städtische Galerie

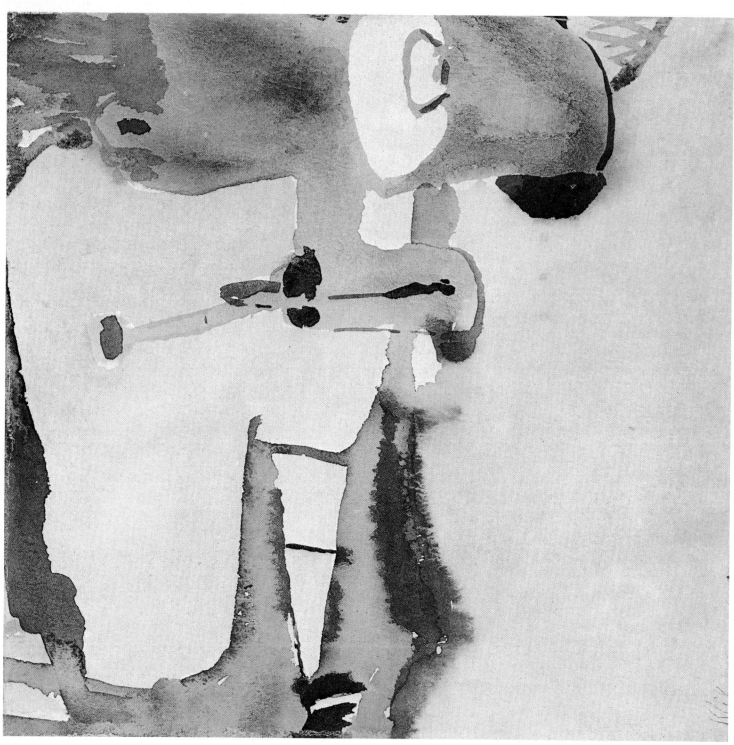

42. PAUL KLEE: *Garden Still-Life with Watering Can.* 1910. Munich, Städtische Galerie

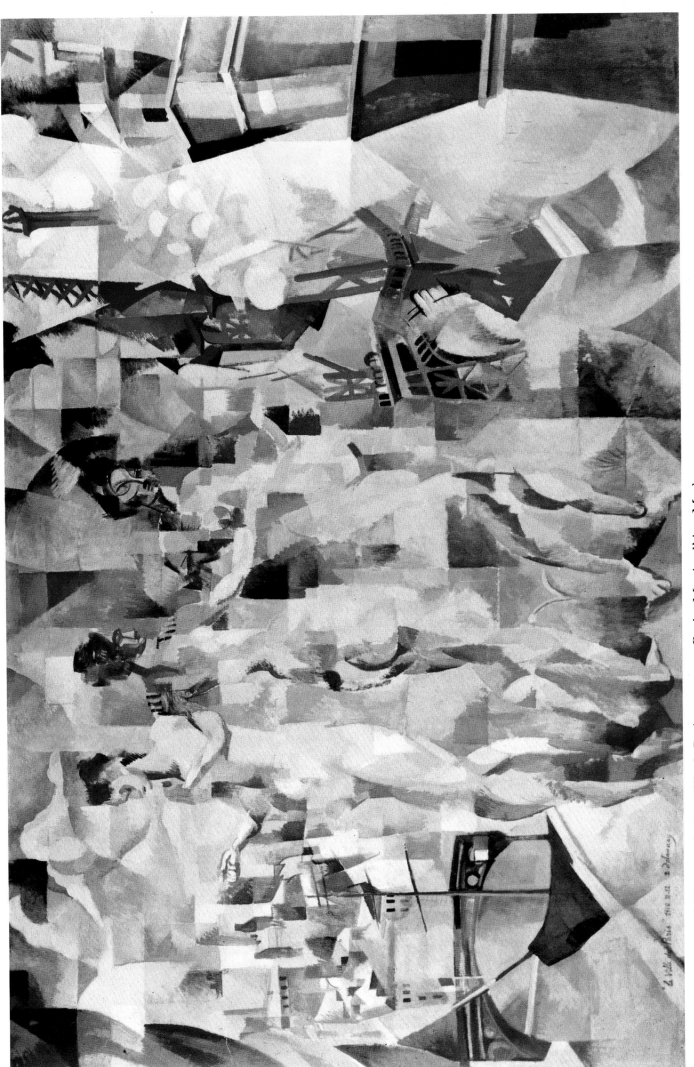

43. ROBERT DELAUNAY (1885–1941): *La Ville de Paris*. 1910–12. Paris, Musée d'Art Moderne

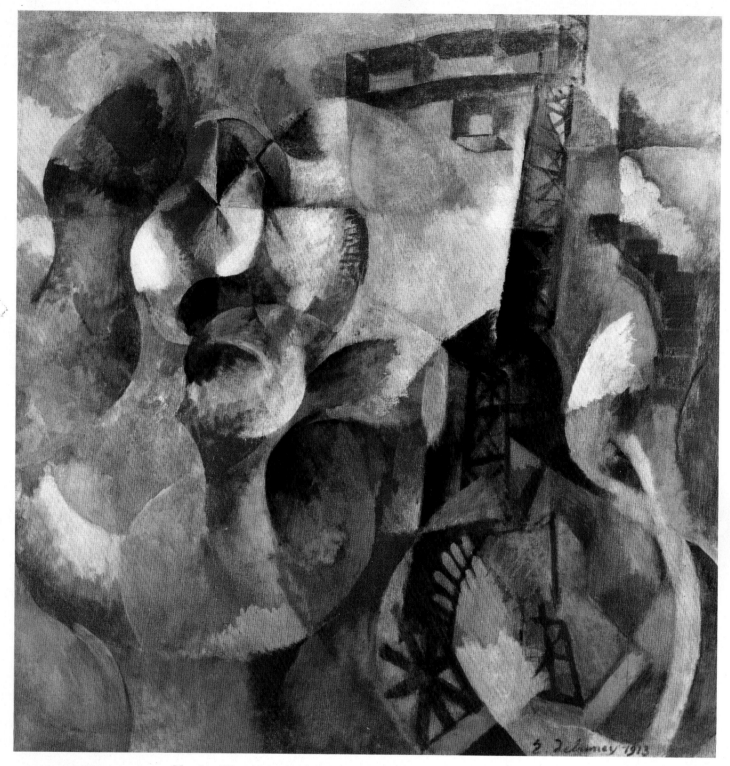

44. ROBERT DELAUNAY: *Circular Forms, Sun and Tower*. 1913. Paris, Private Collection

45. ROBERT DELAUNAY: *Circular Forms*. 1912–13. Paris, Mme S. Delauna

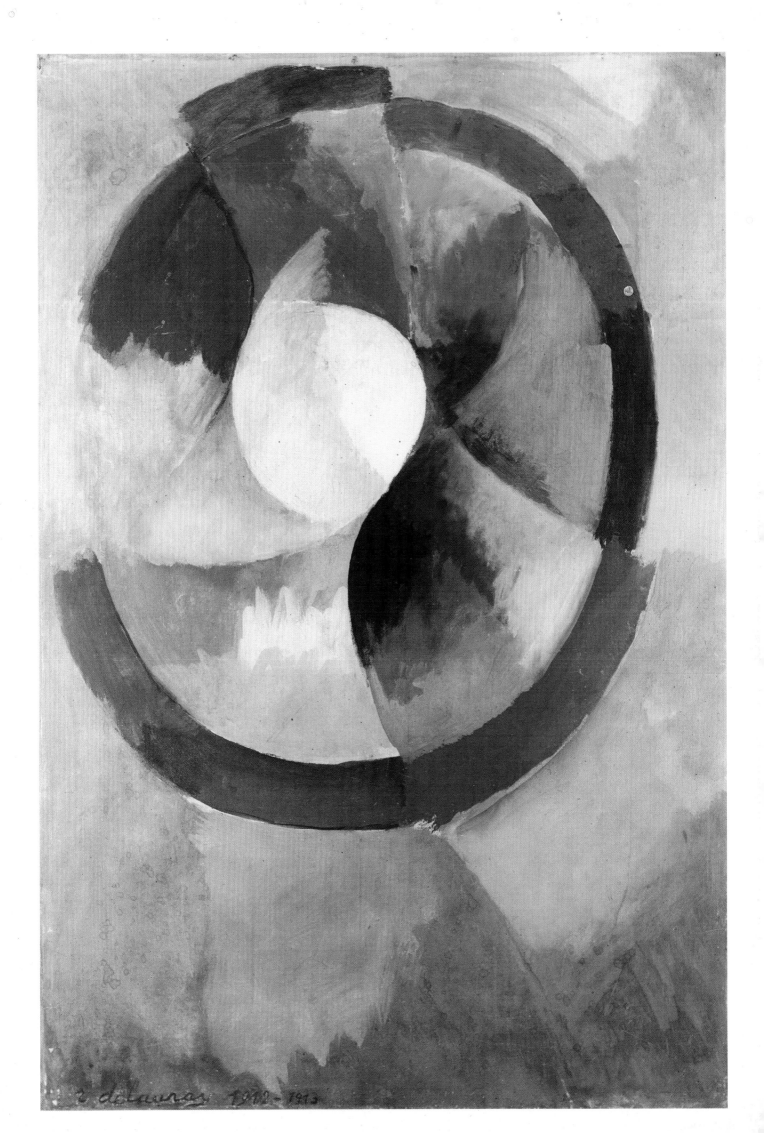

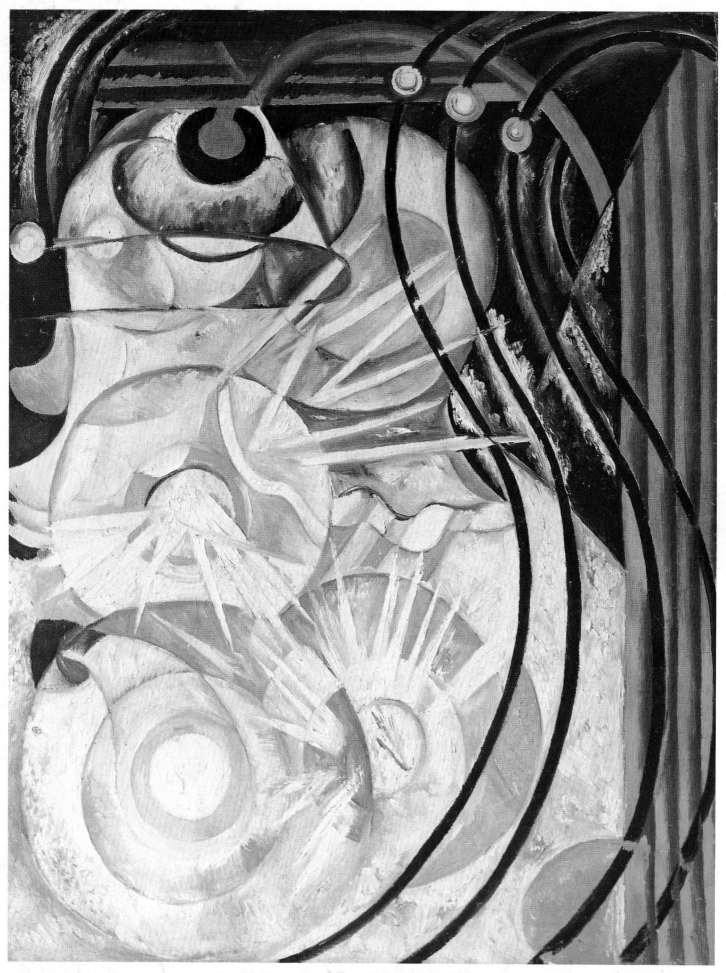

46. NATALYA GONCHAROVA (1881–1962): *Electric Lamps*. 1912. Private Collection

47. ERNST LUDWIG KIRCHNER (1880–1938): *Self-Portrait with Model*. 1907. Hamburg, Kunsthal

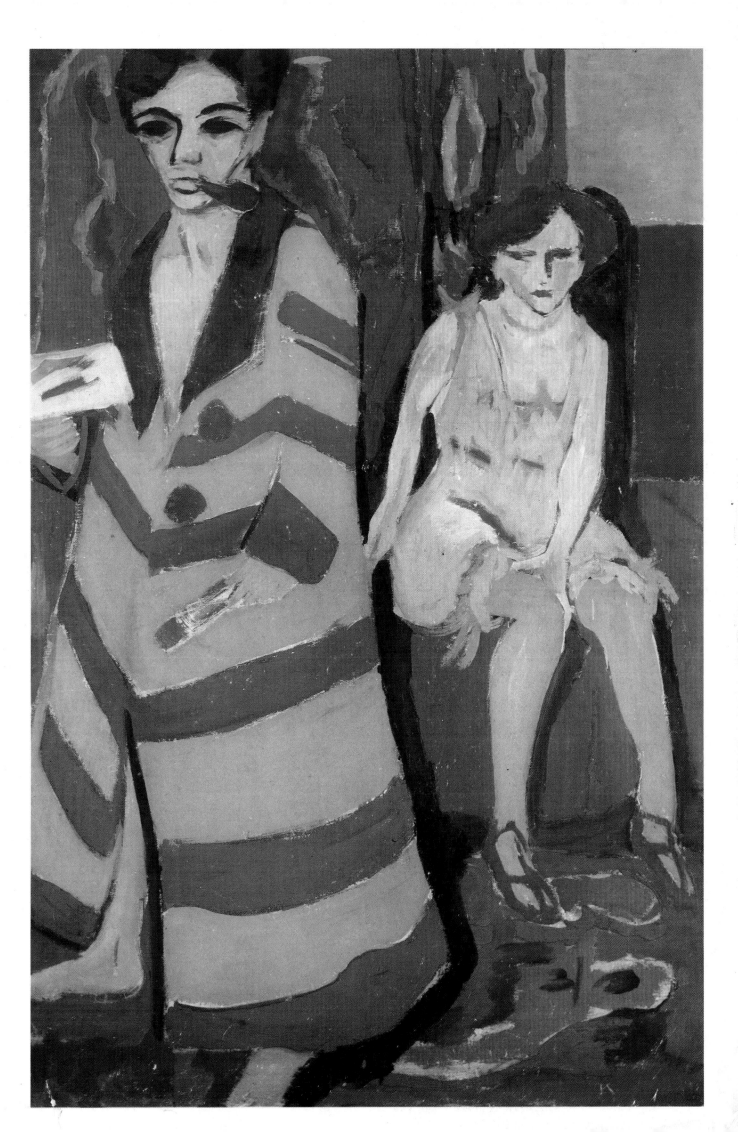

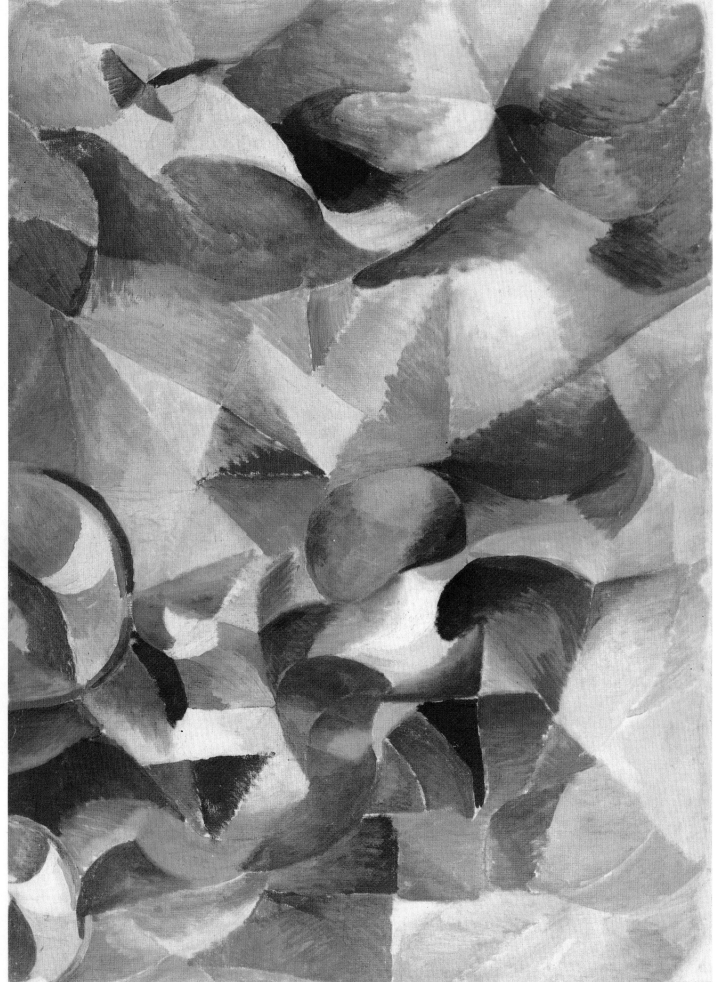

48. SONJA DELAUNAY-TERK (b. 1885) · *Simultaneous Colours* 1913. Bielefeld, Städtisches Kunsthaus